WEB SITE GR

COLOR

GLOUCESTER MASSACHUSETTS

ROCKPORT
PUBLISHERS

THE BEST WORK FROM THE WEB

Jeff Carlson | Toby Malina | Glenn Fleishman

First published in the United States of America by:
Rockport Publishers, Inc.
33 Commercial Street
Gloucester, Massachusetts 01930-5089
Telephone: (978) 282-9590
Facsimile: (978) 283-2742

Distributed to the book trade and art trade in the
United States by:
North Light Books, an imprint of
F & W Publications
1507 Dana Avenue
Cincinnati, Ohio 45207
Telephone: (800) 289-0963

Other Distribution by:
Rockport Publishers, Inc.
Gloucester, Massachusetts 01930-5089

ISBN 1-56496-516-3

10 9 8 7 6 5 4 3 2 1

Designer: The Design Company
Cover Image: Gr8, p. 44

Printed in Hong Kong

Une pierre
eux maisons
nines

introduction

A palette of 216 colors might have daunted any artist except for the pointillist Georges Seurat, but it is the defining scheme for most of today's World Wide Web sites. Some designers rebel against this limitation, but the practical world intrudes.

If you want some sense that your work will appear similarly on many different machines, you must choose a small set of colors, typically from the so-called Web-safe palette. Choosing more than 216 colors, or going nuts and using 24-bit color (millions of colors), means that the majority of viewers will see dithered, pixelated, corrupted renditions of your original intent.

For certain audiences, you can rely on deep color and ignore these limitations. A software company selling three-dimensional animation software deals mostly with folks who have more than the average eight bits of color (256 colors). Similarly, a site that presents art might attract surfers, but can't make a *Starry Night* out of ten blues.

The challenge for all designers is to make each color count, whether you're drawing from a deep pool or a paint-by-numbers scheme. The sites appearing in this book have made design choices that allow them to work within the constraints they've put upon themselves, rather than working outside the frame and allowing Web browser software to interpret colors in whichever way it sees fit.

Some sites choose to push the saturation envelope, taking advantage of the fact that bright colors can fight each other on screen with often surprising results. They borrow from video games, silk-screened posters, television cartoons, and laser light shows. Other pages find great interest in using tiny differences: one shade and its nearest discernible neighbor forming all the contrast on a page.

It's clear that the best sites educate their visitors by giving them a message spelled out in hue and tonality: without even reading the words, we know where we've landed. And unlike a finely-dappled Seurat painting, we don't have to take several steps back in order to get the full picture.

"The challenge for all designers is to make each color count, whether you're drawing from a deep pool or a paint-by-numbers scheme."

title
Bodyflow
URL
http://www.qmm.com.au/hon/
Designer/illustrator/
programmer
Hon Hiew

The Bodyflow site is an excellent example
of how color can be used effectively
without dumping it over every inch of
screen space. Each section carries its own
color designation. Although not necessary
for navigation (locations are prominently
displayed in text form and in each window
is title bar), the color consistency adds a
smooth professionalism to the site. Plus,
the pages load extremely fast.

The AT&T Online Games
presented by
AT&T WorldNet Service

The AT&T
Olympic Games Connection

AT&T

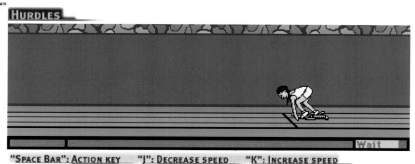

HURDLES

Wait

AT&T Global
Olympic Village
Live

AT&T Olympic
Games
Switchboard

Olympic
Museum Tour

Athlete
Home Pages

The AT&T
Online Games

The AT&T
Centennial
Olympic Games
Send-off

To The AT&T
Olympic
Home Page

"SPACE BAR": ACTION KEY "J": DECREASE SPEED "K": INCREASE SPEED

At the starting gun (or, if you don't have sound, the green light), hit the space bar to start. Watch the speed meter to check your pace. Higher speeds gain higher scores, but speed makes hurdling harder. If you nick the hurdle, you'll stumble, lose time, and look very uncool.

SCOREBOARD

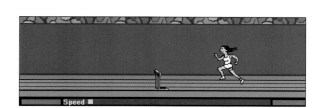
Speed ■

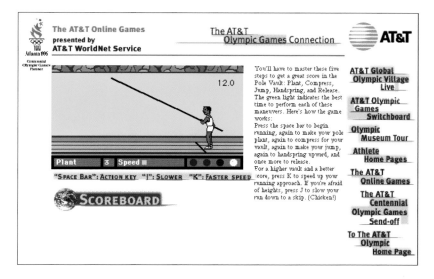

The AT&T Online Games
presented by
AT&T WorldNet Service

The AT&T
Olympic Games Connection

AT&T

12.0

You'll have to master these five steps to get a great score in the Pole Vault: Plant, Compress, Jump, Handspring, and Release. The green light indicates the best time to perform each of these maneuvers. Here's how the game works:
Press the space bar to begin running, again to make your pole plant, again to compress for your vault, again to make your jump, again to handspring upward, and once more to release.
For a higher vault and a better score, press K to speed up your running approach. If you're afraid of heights, press J to slow your run down to a skip. (Chicken!)

AT&T Global
Olympic Village
Live

AT&T Olympic
Games
Switchboard

Olympic
Museum Tour

Athlete
Home Pages

The AT&T
Online Games

The AT&T
Centennial
Olympic Games
Send-off

To The AT&T
Olympic
Home Page

Plant 3 Speed ■ ● ● ○

"SPACE BAR": ACTION KEY "J": SLOWER "K": FASTER SPEED

SCOREBOARD

Title
AT&T 1996 Olympic Games
URL
http://www.olympic.att.com/
Design Firm
Modem Media
Creative Director
Joe McCambley
Associate Creative Director
David J. Link
Art Directors
Tracy Long, Stefanie Trinkl
Producers
Joseph Salvati, Glen White,
Bob Carelli

Can you use a lot of color and still get good performance? Definitely. Although the site looks like a bandwidth-waster, the frugal color palette used here keeps download times to a minimum. Particularly eye-catching are the Shockwave-based online games, with bright, pixelated graphics that respond to your commands.

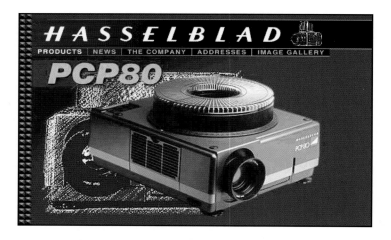

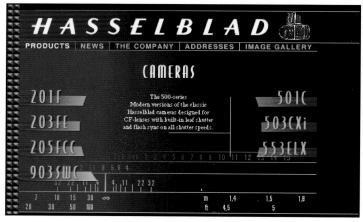

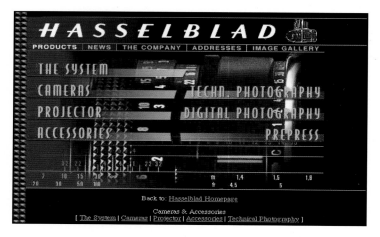

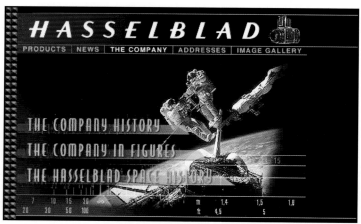

title
Hasselblad
URL
http://www.hasselblad.se/
Design firm
Adera Digital Media AB
Designers
Jaanus Heeringson, Ola
Carlberg
Illustrators
Jaanus Heeringson,
Laszlo Nagy
photographers
Jens Karlsson,
Victor Hasselblad AB
programmers
Jaanus Heeringson,
Ola Carlberg, Thomas Friberg

As one would expect from a
leading manufacturer of
photographic equipment, the
images on Hasselblad's Web site
are superb. However, one aspect
that makes them work so well
is the tightly controlled color
palette that drives the site.
Blue and orange are prominently
featured in the navigation as
well as many of the product shots.

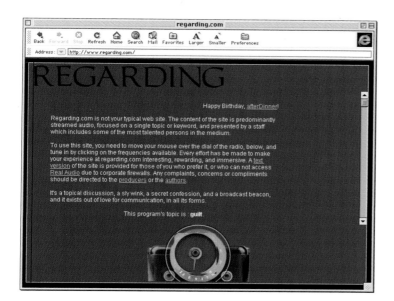

Title
Regarding.com

URL
http://www.regarding.com/

Design Firm
Hushville Interactive

Designers
Alexis Massie,
Gregory Alkaitis-Carafelli

Authoring Platform
Mac

Serious themes require serious colors. Regarding covers issues through audio explorations, and the metaphor is a dark, comfortable room, where one might tune in the dark Bakelite radio. The link color picks up from the brass color of the dial; the background green provides enough contrast for the link color to stand out, as well as the reversed type.

TITLE
BRODY electronic books
URL
http://www.newmedia.co.
at/brody/e_books/
DESIGN FIRM
BRODY newmedia
DESIGNERS
Florian Brody, sarah
Anastasia Hahn

Color comes from light, yet it is rare to see light expressed on the Web. One of the notable aspects of this site's color is the way the designers have introduced a virtual light source at the left edge of the screen. Although most apparent on the opening page, subsequent pages employ a soft transition between white and light olive that soothes the eye and draws its gaze.

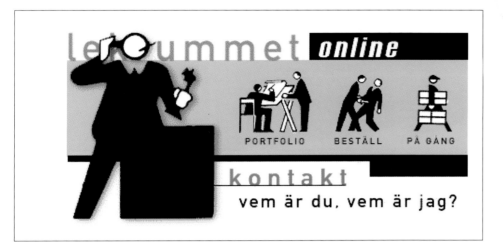

title
Lekrummet online
URL
http://www.ot.se/lekrummet/
Design firm
Lekrummet Design
Designer
Jorgen Joralv
photographers
Mikael Wehner, Jens Petersen
programmers
Jorgen Joralv, Alex Picha

Demonstrating that basic is often better, the color scheme of Lekrummet Online is easy on the eyes and quick to load. Rather than fighting for screen space with every color in the palette, this page's two dominant colors are striking on a simple, white background.

тιτle
Indulgent Arts Magazine
URL
http://www.indulgent.com/
Design firm
C.A.P.
Designer/Illustrator
Rhonda Anton
Photographer/Programmer
Craig Bramscher

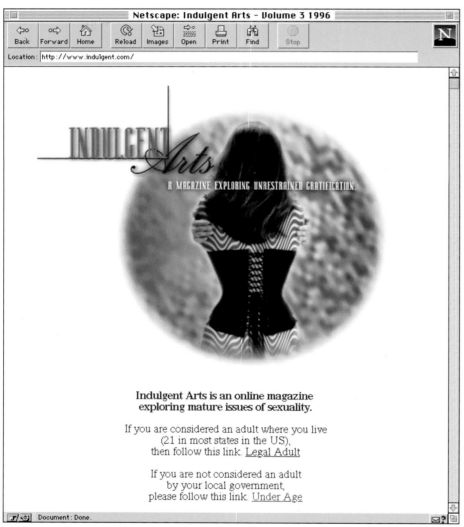

Indulgent Arts imparts a clean
visual style using slightly more
than a handful of main colors.
Pairing gold and maroon warms
up the otherwise stark, white
screens; dark-purple accents
serve to stabilize the open-ended
navigation and provide direction.
All of the images load quickly
due to small color palettes.
The exception is the front-most
image, which first loads a
grayscale preview to hold
the viewer's attention.

Welcome to the Net's first, free hi-fi music archive.

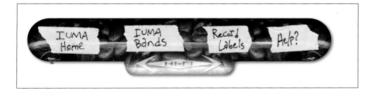

title
 Internet Underground Music Archive
 URL
 http://www.iuma.com/
 Designers
 Brandee Selck, David Beach
 programmer
 Jeff Patterson

Music is an eclectic field, so it's no surprise that the Internet Underground Music Archive (IUMA) boasts a colorful site. Each page has its own variation of the site's navigation bar. Particularly striking is the extensive use of texture throughout, from the swirled stone framing the opening navigation graphic to the lightly buttered toast in the publications page.

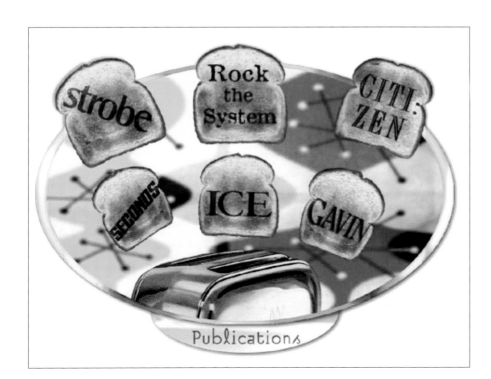

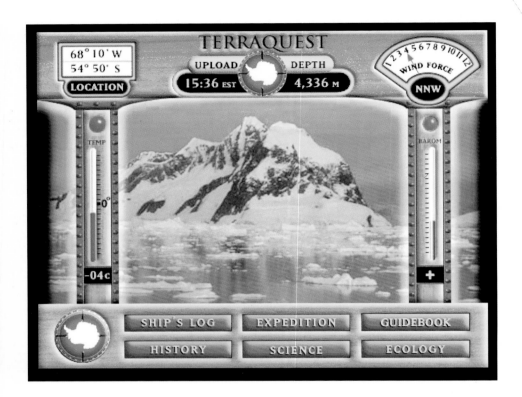

title
mountain travel · sobek's
virtual antarctica
url
http://www.terraquest.
com/va/index.html
designer
brad johnson
principal photographer
jonathan chester

The View from the Bridge page
of the Virtual Antarctica site is
most interesting not because of
its faux-wood grain, but because
of its approach to displaying the
simulation. No attempt has been
made to create a photorealistic
bridge: edges are smoothly
rounded, the windows are
not distorted or subjected
to perspective. The color
here is deliberately soothing
and welcoming.

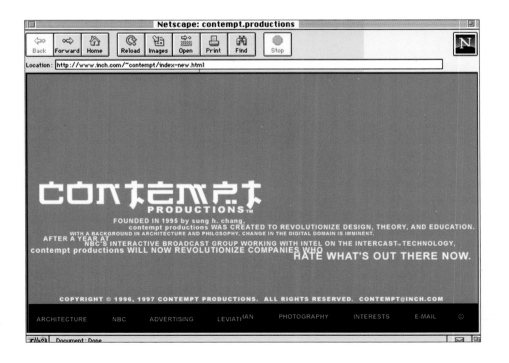

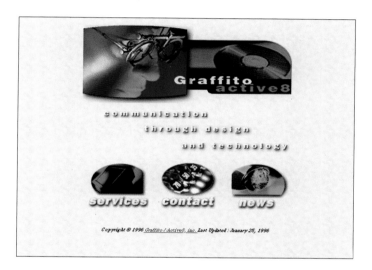

title
 Graffito/Active8
 URL
 http://www.gr8.com/
 Design firm
 Graffito/Active8
 Designers
 Tim Thompson,
 Jon Majerik
 Illustrator
 Josh Field
 photographers
 Ed Whitman, Taran Z,
 Michael Northrup
 programmer
 Jon Majerik

You don't often see these color combinations on the Web. Deep-orange, dark-maroon, violet, and organic-green pairings make the site's atmosphere unnerving, but not quite jarring. Eye-catching, yes, but hard to tell at first just what has grabbed your attention.

title
 contempt productions
 URL
 http://www.comtempt.net/
 Design firm
 contempt productions
 Designer
 sung H. chang

Everything about the Contempt Web site suggests a desire for power and control. Its colors strike at extremes: stark, white text on a deep-red background, supported by a foundation of black. Visitors must delve a few layers into the site before the red gives way to violets and other hues.

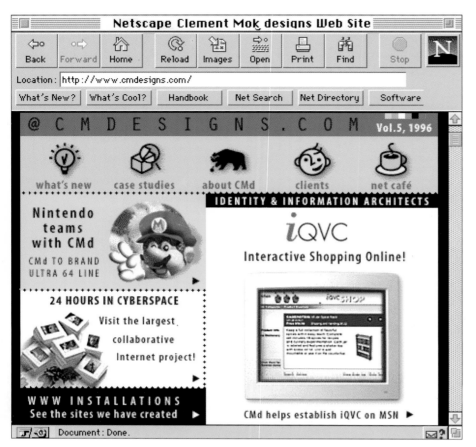

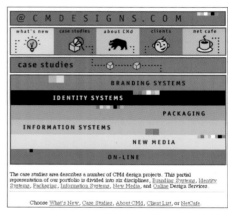

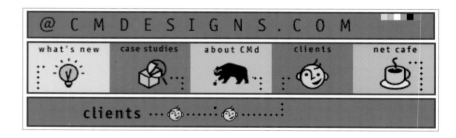

Title
studio Archetype
(formerly clement
Mok designs)
URL
http://www.cmdesigns.com/
Design firm
studio Archetype
producer
sheryl Hampton
creative Director
clement Mok
Associate creative Director
claire Barry
Illustrator
Andrew cawrse
programmers
Mark Anquoe, Michael clasen,
stephan Bugaj

Bright colors not only make these pages pop, they also function as unobtrusive navigational aids and content separators. The tiered subsystem of sections is a straightforward guide to where in the site the visitor is located, while the small color swatches in the upper-right corner make it easy to jump to other sections and do not waste screen real-estate.

title
Home Financial Network
URL
http://www.homenetwork.com/
Design firm
The Design Office Inc.
Designers
Yung Beck, Dave Green, Andrea
Flamini, Joe Feigenbaum
Programmer
Andrea Flamini

Backgrounds can have the most impact on a page, but are arguably the hardest elements to create successfully. The raised credit-card-like background here provides visual variety to each screen, while adding the cachet of monetary sophistication and security.

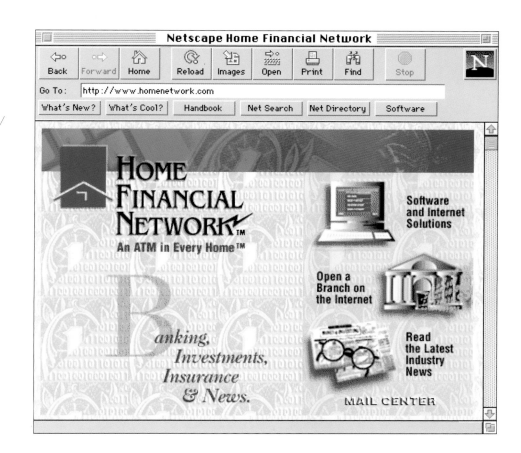

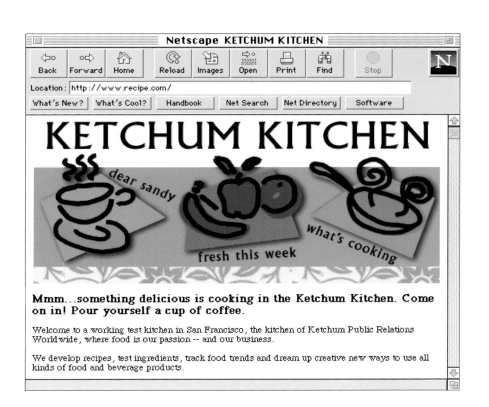

title
Ketchum Kitchen
URL
http://www.recipe.com/
Design firm
Red Dot Interactive
Creative Director
Judith Banning

This site, which has held up well since the early stages of Web design, relies on color and patterns to draw the visitor, rather than the frames, tables, and other trappings of modern Web design. The straightforward HTML loads quickly, as do the controlled color palettes, which impart the warmth of a premium kitchen.

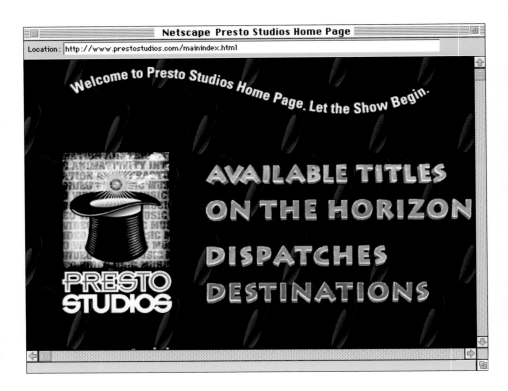

Title
presto studios

URL
http://www.prestostudios.com/

Design Firm
presto studios

Designers
Frank Vitale,
Eric Fernandes

Programmers
Eric Fernandes,
Prakash Kirdalani

Although the multicolored blends decorating the logo and titles are eye-catching, it's the background pattern that makes this site attractive. Repeating a single object is usually a fatal blow to any page, but here, the soft hues of the repeated logo are accentuated by the page's graphics.

Title
DigitalFacades
URL
http://www.dfacades.com/
Design Firm
DigitalFacades
Designer
oliver chan
programmer
jane Lin

It's always refreshing to find sites that use a single color effectively, as in this example. It allows your eye to be drawn immediately to the navigation, while still savoring the texture of multiple images. Hints of more color appear as you get further into the site, culminating in the site's gallery: The single color gives way to the full-colored examples, which now have more emphasis.

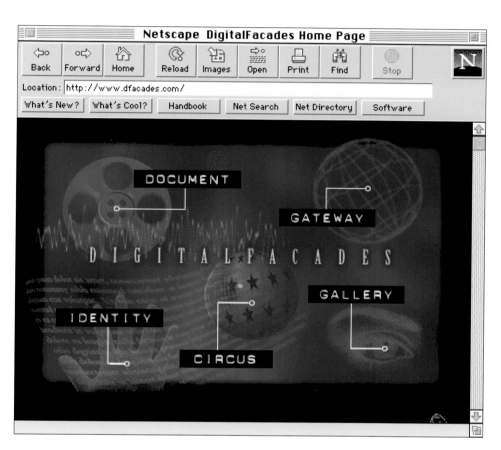

"You all look like happy campers to me. Happy campers you are, happy campers you have been, and, as far as I am concerned, happy campers you will always be."

Vice President Dan Quayle, to the American Samoans, whose capital Quayle pronounces "Pogo Pogo"

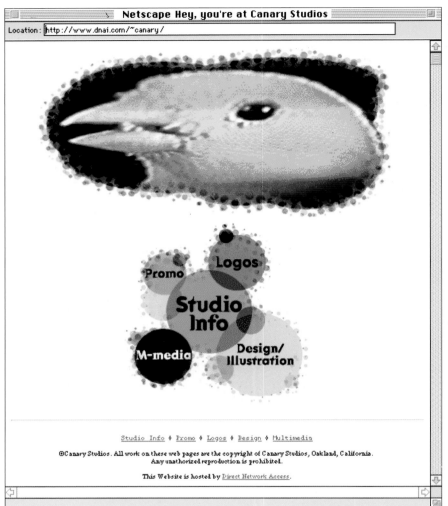

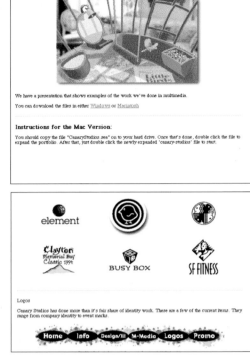

We have a presentation that shows examples of the work we've done in multimedia.

You can download the files in either Windows or Macintosh.

Instructions for the Mac Version:

You should copy the file "CanaryStudios.sea" on to your hard drive. Once that's done, double click the file to expand the portfolio. After that, just double click the newly expanded 'canary-studios' file to start.

Logos

Canary Studios has done more than it's fair share of identity work. These are a few of the current items. They range from company identity to event marks.

TITLE
canary studios
URL
http://www.
canary-studios.com/~canary/
DESIGN FIRM
canary studios
DESIGNERS
ken Roberts, carrie english
ILLUSTRATOR
carrie english
PHOTOGRAPHER
Robert sondgroth
PROGRAMMER
ken Roberts

Who says a canary must be colored canary? The oversaturated image at top suggests that what you'll find here is beyond the normal range of design. The splotchy navigation elements, a seemingly randomized collage of color halftones, reinforce this notion. Once inside, however, the cleanliness of the designers' work adds a professional polish to their image.

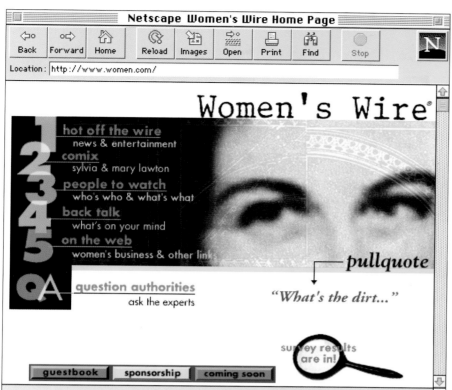

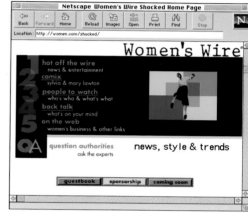

title
women's wire
URL
http://www.women.com/
Design Firm
Lisa Marie Nielsen Design
Designer
Lisa Marie Nielsen

Bright colors are often unfairly reserved for ultra-cheerful sites that occasionally repel viewers due to an overdose of sugarcoating. Not so here. The bright colors on these pages, combined with the grayscale photographs and bitmapped texture, create an upbeat look that respects the intelligence of the site's target audience.

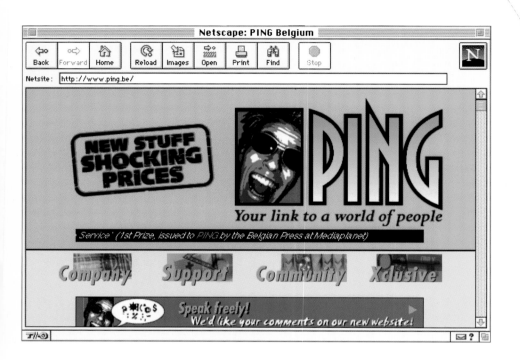

title
ping belgium
URL
http://www.ping.be/
design firm
ping belgium
designers
Dirk zurngenter,
peter van hees,
bernard gillbrecht
illustrator
bart De neve
photographer
peter van hees
programmers
Mark van Hamme,
peter van hees,
Marchteet garrels

If you thought neon colors went out with the 1980s, look here. Even if the logo didn't feature a screaming green man, the hot pink set against the bright orange would command attention. Subtle? Hardly, and that's clearly the way this site's creators like it.

title
Teknoland
URL
http://www.teknoland.es/
Design firm
Teknoland
Art Director
David L. cantolla
programmers
colman Lopez,
jesus suarez,
Rafael sarmiento,
cesar M. Ibanez

The designers of Teknoland have done a good job of matching the style of imagery and color with the subject matter: The blue, pixelated, radio dishes evoke the ephemeral nature of radio transmission. More impressive are the interlaced backgrounds in the TV Teknoland area, which combine colored lines in overlapping patterns that almost shimmer—without animation—like a television display viewed up close.

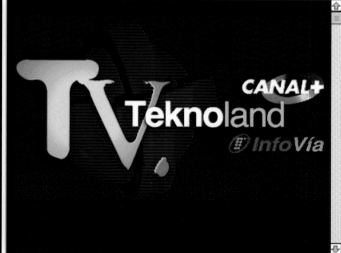

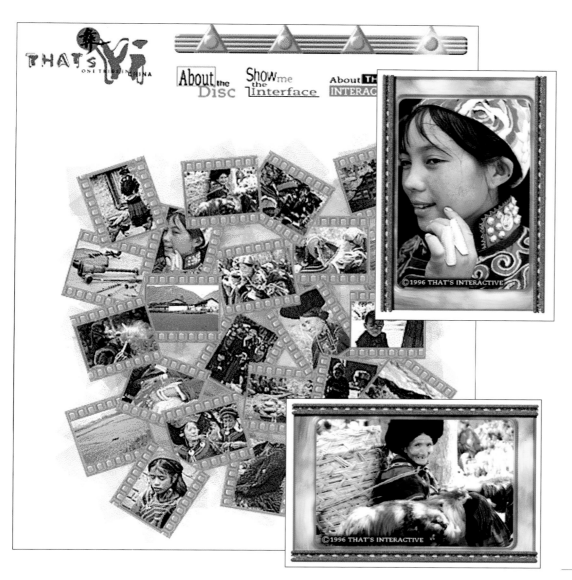

TITLE
That's Interactive
URL
http://www.thats.com/
DESIGN FIRM
That's Interactive
Limited
DESIGNERS
Foley Kwok, Joey Pun
PRODUCER
Stephen Kam
PROGRAMMER
Canty Lee

This site is awash in multicolored images, but it isn't the variety of colors that's notable. The graphics on these pages are severely pixelated, adding a grainy visual texture throughout. This technique adds variety to ordinary elements, such as the underlines below the words *Y, Qiang, Tibetan,* and *Beijing*: Why stick with one color when you can use hundreds?

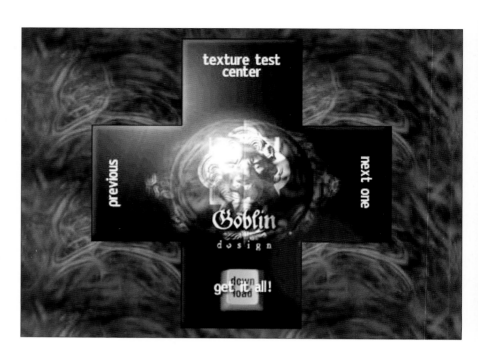

title
goblin design
URL
http://www.goblindesign.com/
design firm
goblin design
designer/illustrator/
programmer
silas tobal

Good color management is no easy
trick, especially on the Web, where the
whims of one browser's color palette
will contradict that of another. That's
why the swirling mists of color used
here are eye-catching. Even on monitors
set to display 8-bit (256 colors),
the nuances of the many colors
translate well.

IMAGES AT **WORK**

Examples of: Still Life

SHOW ME!

**CONTACTS ABOUT US
EMOTIONS WORK PEOPLE**

WHERE DO YOU WANT TO GO?

Looking for feelings like: Exotic

Captured in: Portrait

SHOW ME!

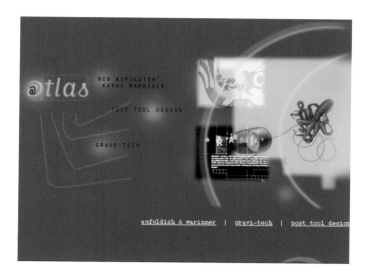

title
@tlas
URL
http://www.atlas.organic.com/
atlas/win97_f3.html
design firm
@tlas web design
senior designer
Amy Franceschini
co-designer
David Karam
programmer
Michael Macrone

Using a different colored background isn't necessarily notable on the Web. What makes @tlas different in this respect is the way the background and foreground elements blend well together. The blurs provide a soft context upon which rests the harder-edged highlights of each page.

title
camera link AB
URL
http://www.cameralink.se/
design firm
Robot
designers
Raket/Robot
programmer
Jesper weissglas

With a potential palette of millions of colors, why choose to create a largely grayscale Web site? As aficionados of classic black-and-white movies are aware, the starkness of grayscale can bring more drama to a medium dominated by color. When colored images are introduced, they make a bigger impact.

title
pittard sullivan
URL
http://www.pittardsullivan.com/
design firm
pittard sullivan
designers
aaron king, soo chyun,
ron romero
programmers
bryan keeling, marvin price

The core of Pittard Sullivan's site is nothing but text and color, a combination of two stark elements guaranteed to garner attention. Opening with a simple two-color animation, the rest of the site displays columns of colors, digital crepe paper that the visitor peers through to view the rest of the site's content.

TITLE
Blind visual propaganda
URL
http://www.blind.com/
home.html
DESIGN FIRM
Blind visual propaganda
DESIGNERS
christopher Do,
jessie Huang,
michelle Dougherty
photographer
Fiel valdez
programmer
Arthur Do

With its use of solid blacks on a bare background, the pages of the Blind.com site reflect the starkness of black-and-white photography. The yellow-green background is neither warm nor cold, but acts rather as a stabilizing liquid to lift the varied-colored elements found deeper in the site.

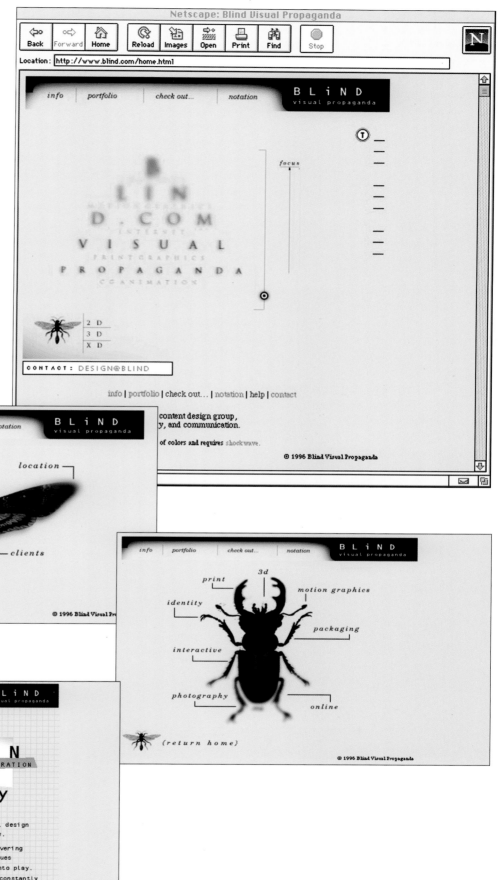

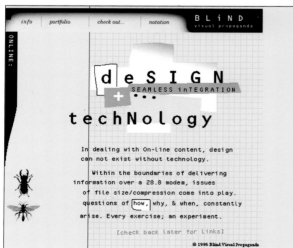

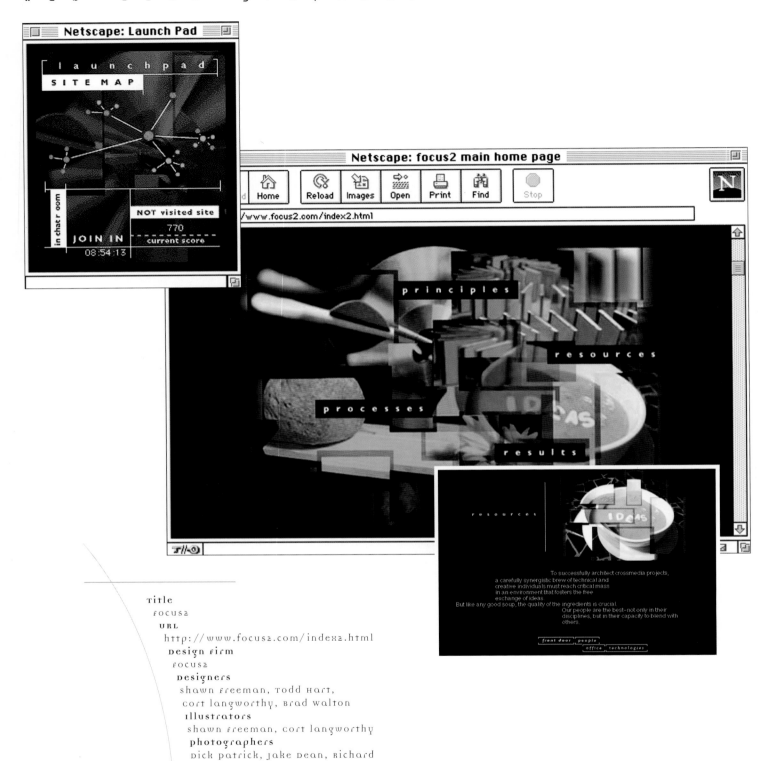

Title
FOCUS2
URL
http://www.focus2.com/index2.html
Design firm
FOCUS2
Designers
shawn freeman, todd hart,
cort langworthy, brad walton
Illustrators
shawn freeman, cort langworthy
photographers
dick patrick, jake dean, richard
seagraves
programmers
david adams, walker hale iv

Even when limited by the Web's
216-color, browser-safe palette, it's tempting
to throw as much color as
possible at a Web site—like having
the jumbo set of Legos rather than
one of the little kits. However, the designers
here know the value of
reining in excessive color, and the
duotoned title images prove it.

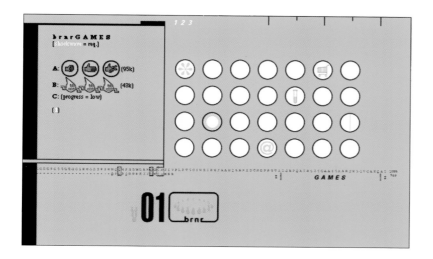

Title
BRNR Labs
URL
http://www.brnr.com/
Designer
Michael French

The first noticeable color
element here is, of course,
the bright background; second
are the white circles. Tying the
two together are the gray icons
and accents (notice the BRNR
logo, gray against the background
instead of white) that are the
featured elements of the main
page. These objects get noticed
not because of their color,
but because of the disparity
between the other two.

Title
Kjetil Vatne Graphics+Design
URL
http://www.prodat.
no personer/kjetil_vatne/
Design Firm
Kjetil Vatne
Graphics+Design
Designer
Kjetil Vatne

To illustrate that a medium affects
its content, look to the Web for proof.
The opening pages here are primarily
made up of large patches of solid color,
which compress much better as GIFs.
The bold colors give way to more variety
inside the site, which mixes solids with
blends and patterns.

TITLE
qaswa
URL
http://www.qaswa.com/
DESIGN FIRM
qaswa communications
DESIGNER
Ammon Haggerty

The designers here seem to
have done more with white than
other sites do with fully loaded
color palettes. Using white as a
base, they've carved out sections
that push the brightly colored
icon elements forward. Photoshop
users will recognize the pale
checkerboard background pattern
as that program's default
transparency indicator.

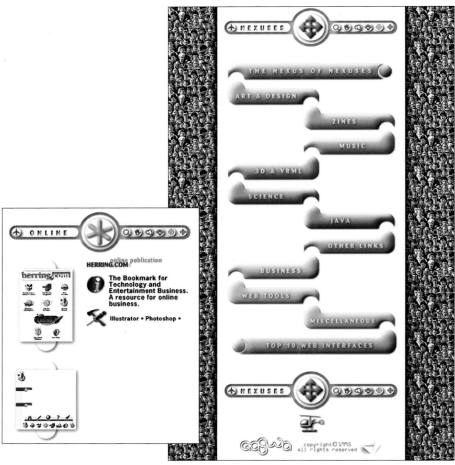

TiTle
Allstar Magazine
URL
http://www.allstarmag.com/
Design firm
N2K Entertainment
Designers
Robert Lord, Trevor Gilchrist,
Michelle Comas, Victor Bornia
Illustrators
Adriane Tomine, J. Otto Seybold
Programmers
Robert Lord, Victor Bornia
Authoring platform
Mac, PC

Allstar magazine uses 1950s colors
(and sickly green on a face) to create
space and evoke a mood of irony mixed
with nostalgia. Past the homepage, the
fake wood-panel brown is repeated in a
corner or side panel to provide consistency.

Title
we make Art Dolls and Automata
URL
http://www.home.earthlink.net/~chomed/
cmcollector.html
Designer/Illustrator/
photographer
chris chomick
Authoring platform
pc

The dolls that appear on each page are subtly cartooned (maybe caricatured) using a comic-book palette on the illustrations in the background and at the header. Each section has a pale tint in the background that plays off the tints in the photographs and illustrations. The marvelous Roland Montague in red velvet always points home.

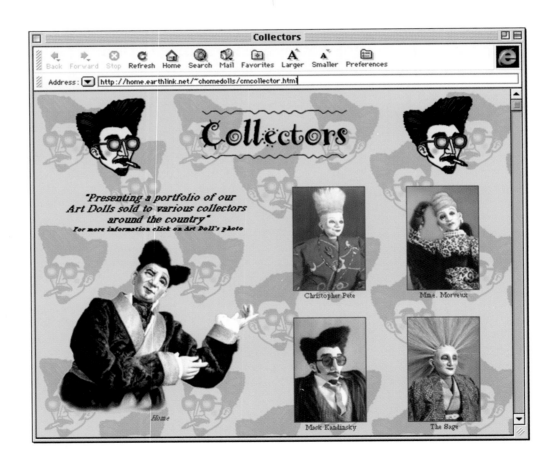

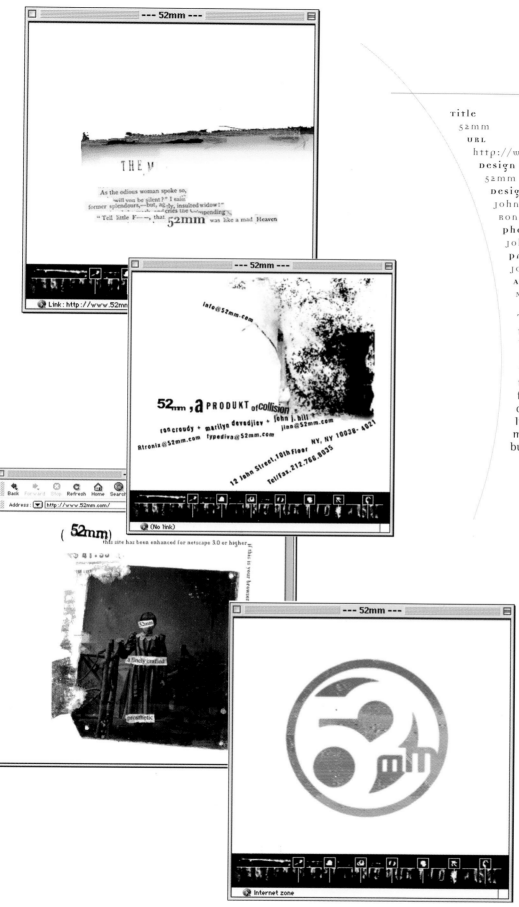

TITLE
52mm
URL
http://www.52mm.com/
DESIGN FIRM
52mm
DESIGNERS/ILLUSTRATORS
John J. Hill, Marilyn Devedjiev,
Ron Croudy
PHOTOGRAPHERS
John J. Hill, Marilyn Devedjiev
PROGRAMMER
John J. Hill
AUTHORING PLATFORM
Mac

These designers effectively bring
the world of photocopier art to the
Internet. Using images with just
gray, faded-newspaper yellows, or
rainbow-photocopy-streaked,
the whole site looks like objects
found in windows years later
or left over in the recycling bin.
It's a consistent aesthetic, made
more pronounced by an occasional
burst of outrageous colors.

title
woodblock
URL
http://www.woodblock.
simplenet.com/
Designer/Illustrator/
programmer
Kha Hoang
Authoring platform
Mac

Look at the distinction of
two grays at the bottom of
the entry page to the site:
the design credit and the
continue link. This is the
epitome of using small
distinctions to indicate
large differences in purpose;
there's no mistaking the
credit for the navigation.
The homepage and
subsequent pages typically
use background colors to
set off type, but pick up
the type color in an
illustration. On the home-
page, this extends to the
ALINK color being the
same as the background,
and the text color matching
the flower's red.

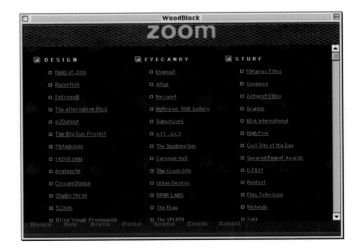

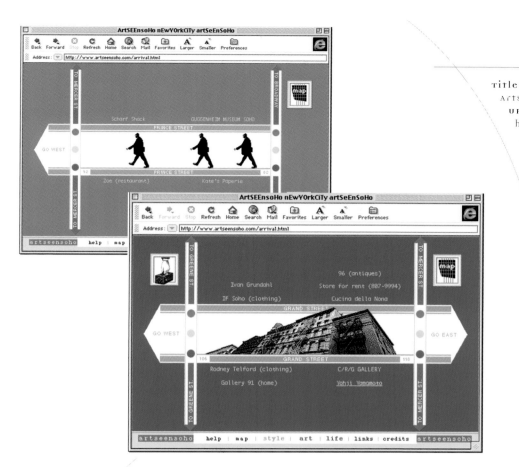

title
Artseensoho
URL
http://www.artseensoho.com/
Designer/Illustrator ,
Tim Trompeter
photographers
peter cunningham,
Tim Trompeter
Authoring platform
Mac

Artseensoho uses color for both navigation and as a strong graphic element. As a navigational feature, they've associated yellow with style, green with art, and red with life. Throughout the geographic part of the site, bright colors bring out a sense of excitement and bustle; this is in counterpoint to the cool-blue photographs running down the middle of each street. The navigational colors live at the intersections of the street maps—just like the green, yellow, and red of a traffic light.

title
Los Angeles county Arts
commission
URL
http://www.lacountyarts.org/
Design firm
Looking/Los Angeles
Designers
Donna Fischer, David Young
programmer
David Young
Authoring platform
Mac

The colors don't have an intrinsic meaning, but they do clearly differentiate one section from another. Each section carries forth its color by using multiple tints for different information areas. Type is knocked out, where necessary, for legibility. The metaphor never breaks down from the home extended out to any subpage of the site. The colors aren't all Web safe, but they're used sparingly enough to avoid real conflicts. Table cells are filled with colors for a quick display.

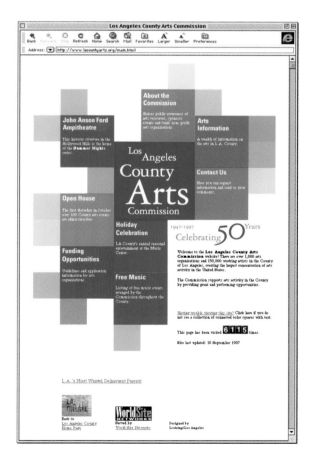

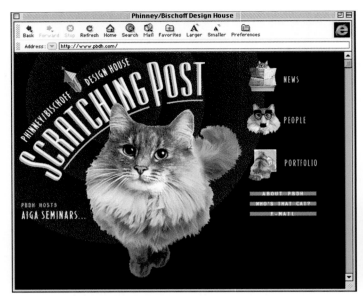

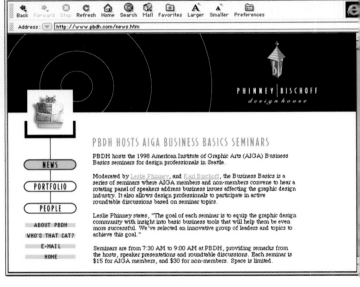

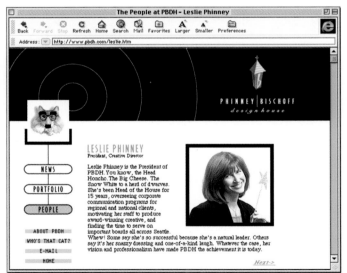

Title
phinney/Bischoff
Design House, Inc.
URL
http://www.pbdh.com/
Design firm
phinney/Bischoff
Design House, Inc.
Designer/illustrator
Neil Robertson
photographer
Karl Bischoff
programmers
Neil Robertson,
Scotty Carreiro
creative Directors
Leslie phinney,
Karl Bischoff
Authoring platform
Mac

With a cat as a mascot, the colors of
fur seem to predominate the site, along
with the corporate identity colors. Using
some clever dithering, the Phinney/Bischoff
Design House site is able to incorporate
photos (of their top cat, Ruby) as well as solid
colors for interface elements. Rather than use
excessive gradations and leave the color display
to the vagaries of a browser, the green, concentric
waves on the homepage were rendered as a
one-color bitmap image.

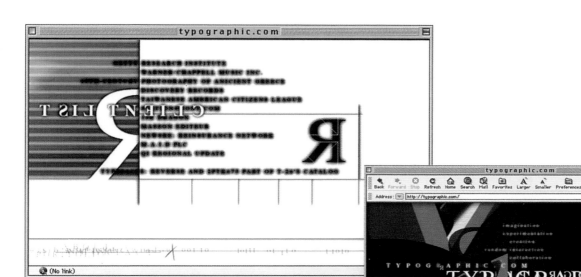

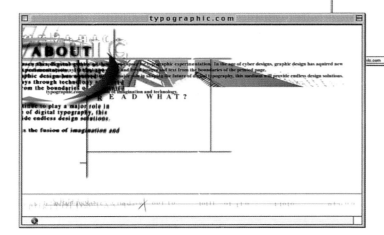

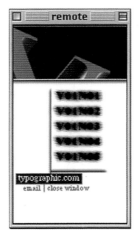

TiTle
typographic.com
URL
http://www.typographic.com/
Design Firm
typographic.com
Designer/Illustrator/
programmer
Jimmy chen
Authoring platform
Mac

This typographic site demonstrates the color of white as well as any print counterpart. White is used effectively to knock-out letters, to fuzz edges, and to emphasize space, especially on the homepage. The only real color present is the beige that is so severely dithered that it creates an incredibly strong vertical motion that almost emulates a line of type.

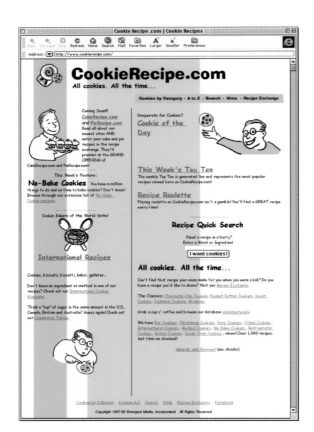

TiTle
cookieRecipe.com
URL
http://www.cookierecipe.com/
Design firm
emergent media, inc.
Designer/illustrator
Yann oehl
programmers
Tim Hunt, kala Anderson, Dan
shepherd
Authoring platform
pc

The instant the background on the page loads, you can smell the Betty Crocker fragrance in the air. Using a palette evoking 1950s homemaker cookbooks, the designers of CookieRecipe.com use a minimalist approach with few colors in background fields and just a few more tints found in the flat-tint illustrations.

Title
Brett snyder:
personal portfolio
URL
http://www.brettnet.com/
Designer/illustrator/
programmer
Brett snyder

The designer created a sleek machine as the interface for the site, and uses subtle shading throughout. The buttons have colored rollovers; when clicked, a new image loads that gives a tiny impression of the button being depressed. The effect is like operating a little handheld video game. The green and red lights at middle right flash in a repeating pattern and reinforce the image of the screen as a machine.

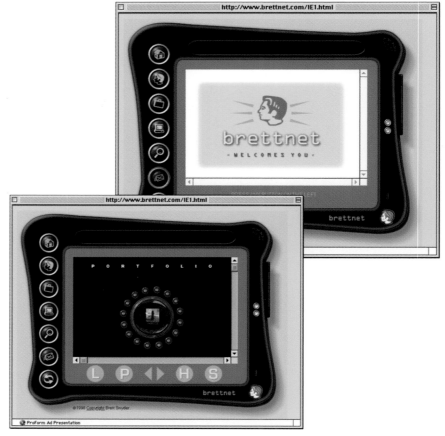

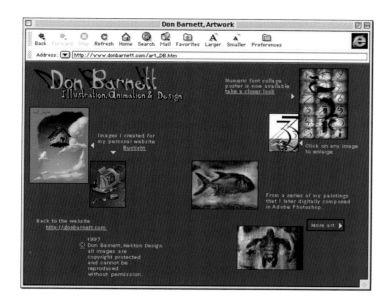

title
Don Barnett
URL
http://www.donbarnett.com/
Design Firm
NEKTON DESIGN
Designer/Illustrator/
Programmer
Don Barnett
Authoring Platform
Mac

Don Barnett creates alternate realities for high-end media companies, like Dreamworks. Part of his designs' charm is in the palette: although his work is often whimsical, like the homepage he calls BugLight, he uses an eerie palette of muddy browns and charcoal grays to set a counterpoint to the otherworldly, but not unpleasant, subject matter.

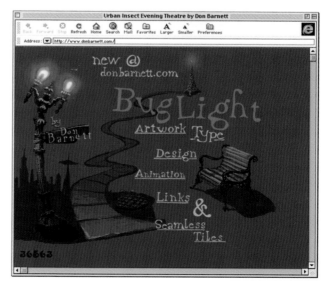

Title
Emergent Media, Inc.
URL
http://www.emergentmedia.com/
Design Firm
Emergent Media, Inc.
Designer
Yann Oehl
Programmers
Tim Hunt, Kala Anderson,
Dan Shepherd
Authoring platform
PC

Each section uses a simple color scheme. Above a vertical split, the color is solid, except for a circular lighter shade on the right. Below the split, the color extends down in the form of part of the company's logo, and a line extends from the left to form an oval container for the word *incorporated*. The scheme renders each section distinct.

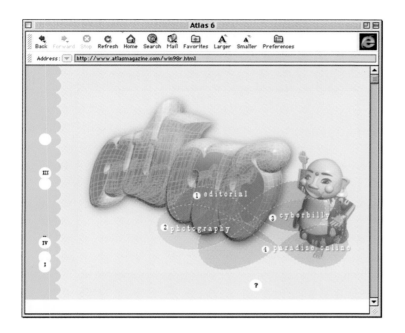

title
Atlas Magazine
URL
http://www.atlasmagazine.com/win98r.html
Design firm
Atlas
Designer/Illustrator
Amy Franceschini
Photographers
Olivier Laude,
Catherine Karnow,
Bob Sacha,
Adam Kufeld, et al.
Programmer
Michael Macrone
Authoring platform
Mac, PC

A homepage that (on some browsers) flashes, reloads, and requires that you lunge to click on links, is made even more bizarre by a really eccentric color palette. There is an aesthetic to going over the top, which Atlas magazine embodies in its editorial and that they have reflected in their site's design.

title
smallprint
URL
http://www.smallprint.net/
Designer/Illustrator/
Programmer
Miika Saksi
Authoring platform
PC

Smallprint is a mysterious set of recursive pages that share a few basic colors across the entire tiny site. Photographs are screened back in a yellowish green, while beige and khaki show up on every page. The dithering of these colors presents strong alternating one-pixel vertical bars that add a corduroy texture to the pages.

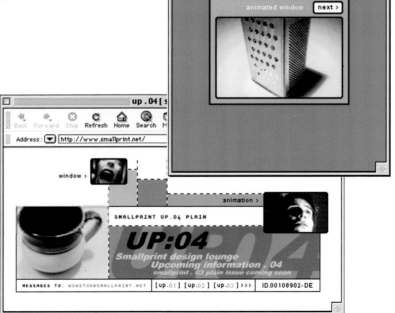

title
frogdesign
url
http://www.frogdesign.com/
design firm
frogdesign
designers/illustrators
frogdesign team
authoring platform
mac, pc

Viewed at 256 colors, frog design's
site is somewhat dithered. But
frogdesign's industrial design
services are aimed at multimillion,
and often multibillion, dollar
companies—they can aim their
site at the select few who can
view the gradations 24-bit color.
The selection bar at the lower right,
simulating the kinds of electronic
devices they design, appears as
backlit plastic when the buttons
are highlighted.

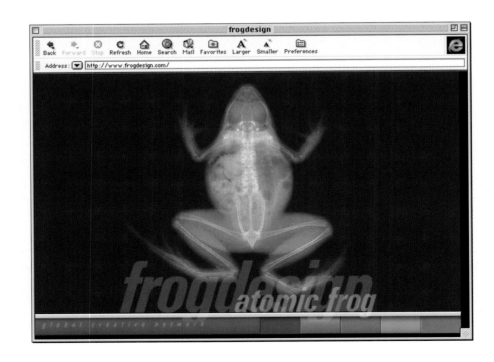

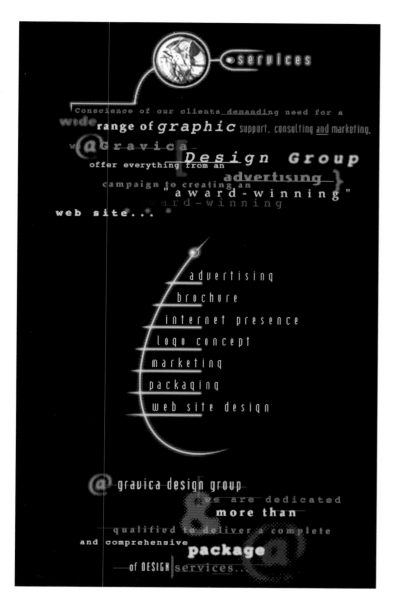

Title
Gravica Design Group
URL
http://www.iliad.com/gravicadesign/
Design Firm
Gravica Design Group
Designers
Michael McDonald,
Charles Molloy
Programmers
Michael McDonald,
Seth I. Rich
Authoring Platform
HTML

Black is often overused on the Web, but the designers at Gravica have lightened up the screen with superb accompanying colors. The reds and oranges combine to produce warm section titles, while the lavender cloud of space dust transitions evenly into the green angel's wings and yellow, swirling nebulae. The black background becomes what it should be: incidental, not overpowering.

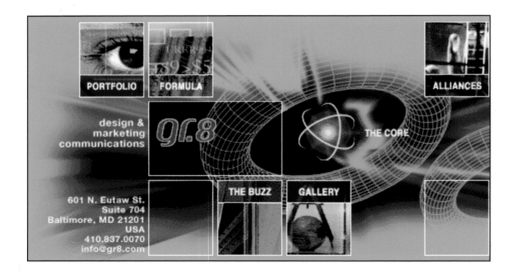

Title
gr8
URL
http://www.gr8.com/
Design firm
gr8
Designers
Morton Jackson,
Heath Flohre, Becky Bochatey,
Chuck Gates, Matt Agro,
Chuck Seeley
Programmers
Chris Walsh, Heath Flohre,
Becky Bochatey
Authoring platform
Mac, pc

It's funny how green wireframes still
seem futuristic to us, even though
they are an artifact of late 70s and
early 80s sci-fi movies. Gr8 displays
a big torus in green outline and
picks up that green throughout
the site. The greens also appear
drawn from Japanese animation.
The knocked-out white frames
add another scientific touch,
making the site map appear
like the table of elements.

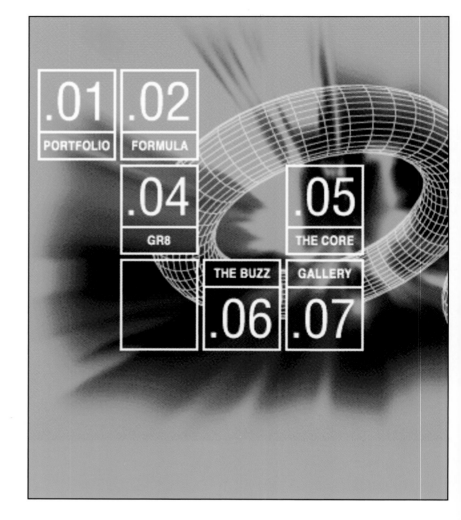

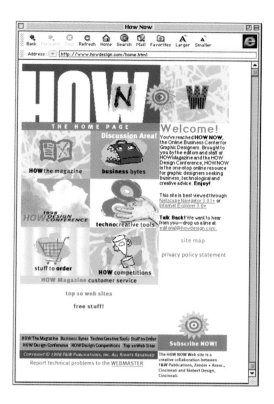

title
HOW Magazine web site
URL
http://www.howdesign.com/home.html
Design firm
F&W publications
Design Department
Designers
stephanie Redman,
Dan pessell
illustrator
siebert Design,
cincinnati
programmer
zender & Associates,
cincinnati
Authoring platform
Mac

Because How's audience is designers and
illustrators, the colors simulate bright
paints. Finer illustrations (like that of the
hand icon for the technocreative tools
section) are surrounded by a thick, colored
outline. The color palette is small and
recycled through each illustration,
concentrating mostly on colors that have
a dried-art-paint feel: a darker blue, a
muddy yellow, and a pastel-muted red.

title
winery.com
URL
http://www.winery.com/
Design firm
The Grapevine
Designer/illustrator
christopher slye
programmer
joe Naujokas
Authoring platform
Mac

Ah, the joys of the grape:
simple and direct. The dominant
color is vine green, and a loosely
clumped pattern of circles in a
bunch at the top contains the
only other splashes of color in the
logos of related sites. The logo uses
a specular, highlighted, and shaded
sphere wrapped with a black vine
to add some visual interest without
creating a jarring effect.

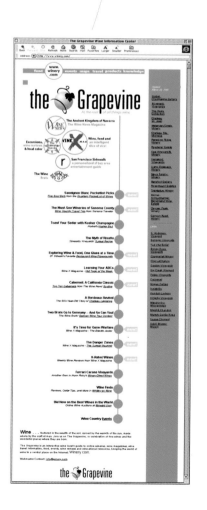

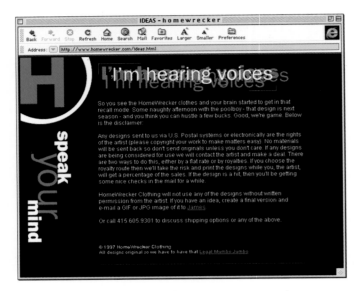

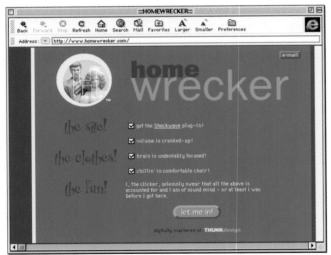

title
homewrecker
url
http://www.homewrecker.com/
design firm
THUNKdesign
designer/illustrator/
photographer/programmer
James Tucker
authoring platform
mac, pc

The designers of this site are obviously playing off the popular bright blue-and-orange lettering and backgrounds used in older advertising campaigns by the software behemoth Microsoft. Images are kept to a minimum, with color, form, and type sending the message. Most of the site is reversed out of black, which is kept from being sepulchral by the site's use of bright, cheery colors.

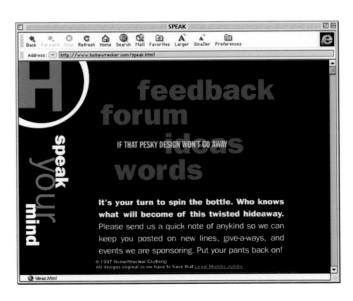

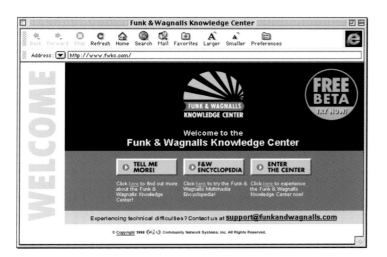

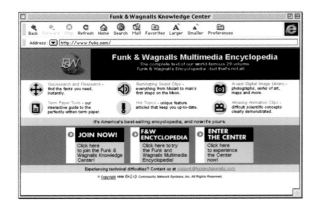

title
virtual community of
tomorrow
URL
http://www.fwkc.com/
Design Firm
community network
systems
Designers
vadim kapridov,
Matvey shapiro, Ephraim
Tabackman
illustrators
vadim kapridov,
Alexei Kazantsev
programmers
Havi Goodman,
Yisrael Naiman, Harry Cohen
project Management
Galen Karten, Kenny Zwiebel
Authoring platform
Mac, pc

Using a minimum of colors that clearly define functions, sections, and even areas of a page, the Funk & Wagnalls Knowledge Center makes it easy to identify features and the current location on the well-structured site. The colors are repeated effectively, too: the blue in the navigation bar is the same used to knock-out the headline and the caption type. The red in the Funk & Wagnalls logo is repeated as the link color in the text.

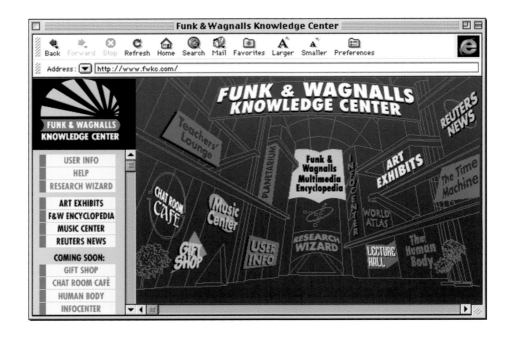

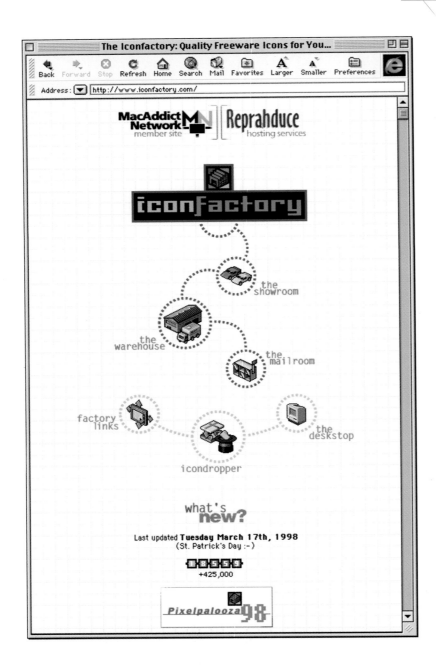

TITLE
The Iconfactory
URL
http://www.iconfactory.com/
Design firm
The Iconfactory
Designers/Illustrators
Corey Marion,
Talos Tsui, Gedeon Maheux
Programmer
Craig Hockenberry
Authoring platform
Mac

Icon Factory has two distinct areas, one for downloads and another for related information, which the colors help divide. As Macintosh icon designers, the colors are all used as solid tints to illustrate simple, but evocative, forms. Although primary and secondary colors are used to call out details—like the arrows on the factory-links icon—less vivid shades of gray and other colors are used to add a slightly more-than-two-dimensional effect.

Title
Funny Garbage
URL
http://www.funnygarbage.
com/about/aboutfg.html
Design Firm
Funny Garbage
Designers
Peter Girardi,
Chris Capuozzo
Illustrators
Todd James, Devin Flynn
Programmers
Fred Kahl, Dan Wyszynski,
Nina Ong
Producers
Fred Kahl, Kristin Ellington,
Esther Robinson
Authoring platform
Mac, PC

Funny Garbage tries to throw you
off the scent of their real content
by using backgrounds that look
like bad photocopies, sporadic
and bright color, and large fields
of white. But careful perusal of
the site shows repeating themes:
jagged borders, thin, wavy lines
that shake through GIF animation,
big, strange shapes, and flashing colors.

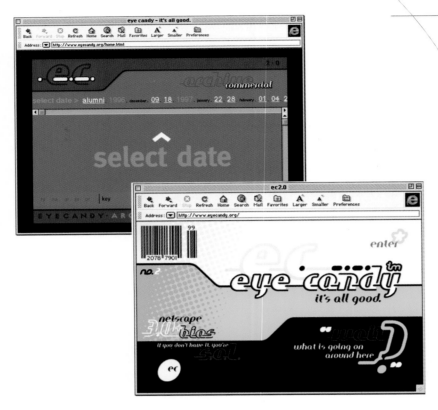

Title
eye candy
URL
http://www.eyecandy.com/
Designer/programmer
josh ulm
Authoring platform
Mac

Being jarring without annoying is a
tough balance, but eye candy uses a
combination of bright colors, fake
halftones, and smooth gradations
to create visual interest that helps
move the browser along and identifies
different sections. Most of the type
and graphics are in a slightly brighter
color than the overall background.

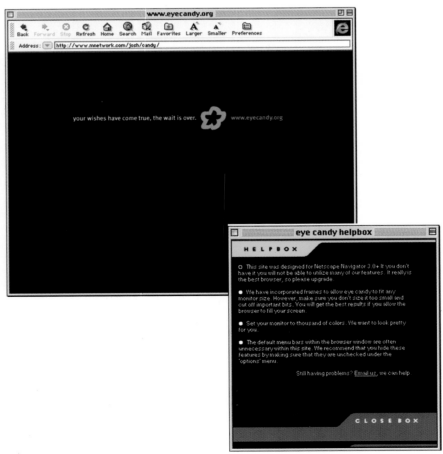

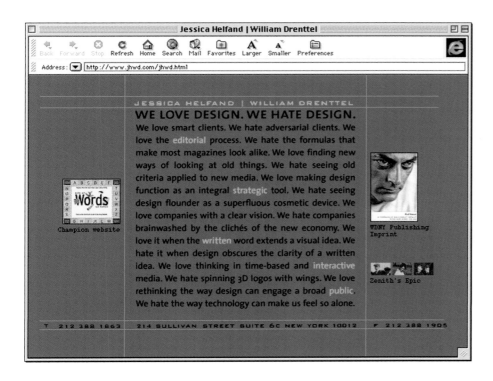

title
jessica Helfand|
william Drenttel
URL
http://www.jhwd.com/jhwd.html
Design firm
jessica Helfand|william Drenttel
Designers
jessica Helfand,
william Drenttel,
jeffrey Tyson
programmers
jeffrey Tyson, steve Bull (JAVA)
editor
Timothy Mccormick
Authoring platform
Mac

What remarkable presentation using (primarily) three colors, plus black and white. The three colors are all drawn from the Web-safe palette, to boot. The dark-green background is not so dark as to render the vibrant neon green and black type illegible. The vertical and horizontal lines appear as a paler shade of the background color, with the neon green used as a strong, but simple, vertical divider on the content pages reached from the homepage.

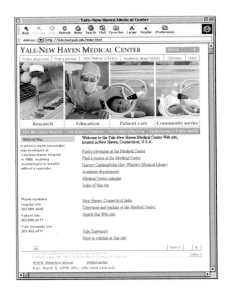

title
Yale-New Haven
Medical Center
URL
http://info.med.yale.
edu/index.html
Design Firm
Center for Advanced
Instructional Media,
Yale University
Designer/Illustrator
Patrick J. Lynch
Photographer
Yale University Biomedical
Communications
Programmer
Sean Jackson
Authoring Platform
Mac

One of the few sites to use
photography of their own events,
Yale-New Haven Medical Center
presents a calm, easy-to-navigate
interface—as it needs to be. The
navigation bars use the same
gray to knock-out white type (for
other, related organizations) and
as positive space for choices that
navigate within the site. The
photographs pick up hospital
colors without making that
into a negative experience:
the light and baby blues of
hospital gowns and scrubs
contrast with warmer wood
tones and grays. They're
not afraid to show a little
excitement, either: a yellow
bar marks noteworthy events.

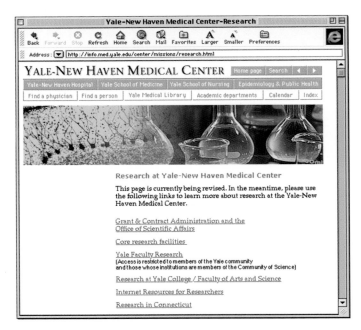

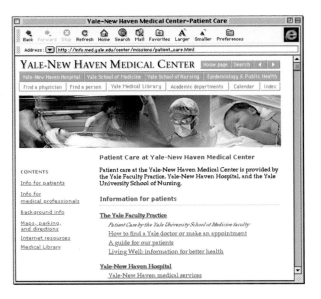

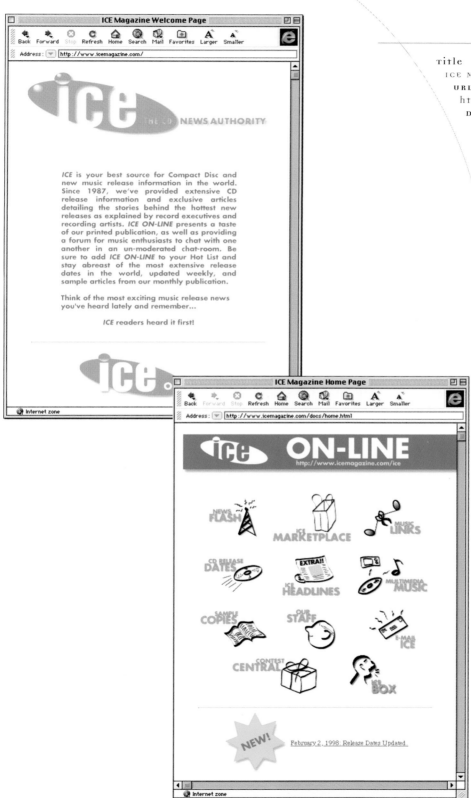

Title
ICE Magazine
URL
http://www.icemagazine.com/
Design firm
ICE Magazine
Designer/Illustrator
Henry Rael Jr.
Programmers
Henry Rael Jr.,
Jacob Rael
Authoring platform
Mac

Simplicity can often seem profound, and by those standards, Ice On-Line seems very deep. The introductory page uses just a couple of colors (plus some shading and highlights). The icons on the main page of the site pick up the same colors to use for links to other sections.

title
curricular computing
URL
http://www.dartmouth.edu/~cc/
Design firm
Dartmouth college curricular computing
Designer/Illustrator/photographer/programmer
sarah Horton
Authoring platform
Mac
images courtesy of photodisc, inc.,
the copyright holder

Five images are used on the home page to this section at Dartmouth College and the details from these colorful images, which evoke the sylvan setting of the school, are repeated as part of the top menu bar on each page. The color of the top of the page is drawn from one of the images as well. Text color on secondary pages isn't overlooked: soft grays are used in less-important textual details and as a backdrop to a text menu appearing on the left of each page of the section.

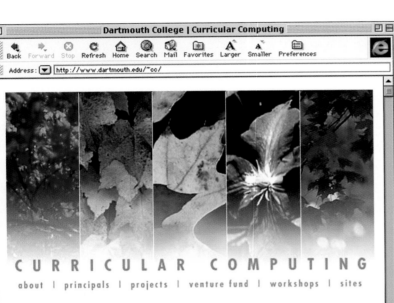

title
parent soup
URL
http://www.parentsoup.com/
Design firm
parent soup
Designer/Illustrator
christina fredericks
programmers
fay ku, tom simpson
Authoring platform
mac

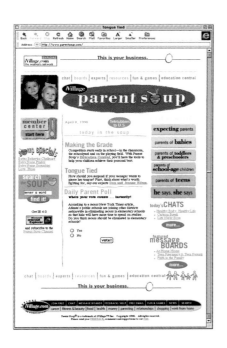

Aimed at parents, not children, the site
tries to have visual sophistication while
alluding to children's art. The color fields
behind navigation elements look like finger
painting—but with clean edges. The lines on
the site are drawn to look like crayon marks
(but are a little straighter than the real thing).
The designers chose to go outside the
Web-safe palette to achieve these richer effects,
but they don't suffer much at eight bits.

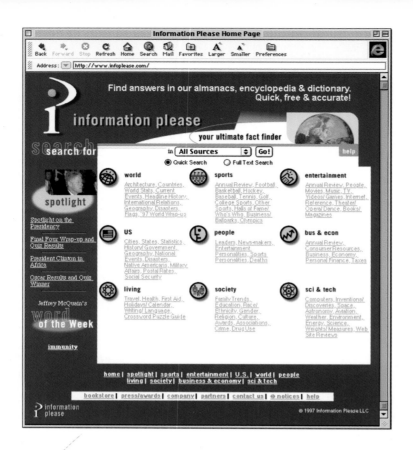

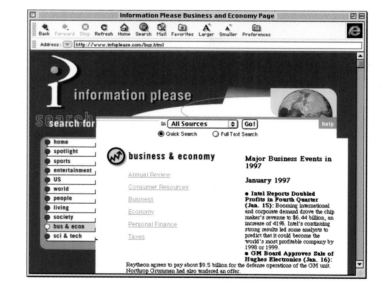

Title
information please

URL
http://www.infoplease.com/

Design firm
stoltze design

Designers
clifford stoltze, susanne hefel,
cynthia patten, rebecca fagan

Illustrator
james kraus

Programmers
boris goldowsky, paul evenson

Authoring platform
mac, pc, unix

It's hard to say why a dark blue makes one
think of an information desk, but there's a
definite association that the designers of
this site play off. The palette is limited to
the information blue, a spotlight yellow, a
text/icon navigation light blue, a top-bar
orange, and very few colors on the globe.

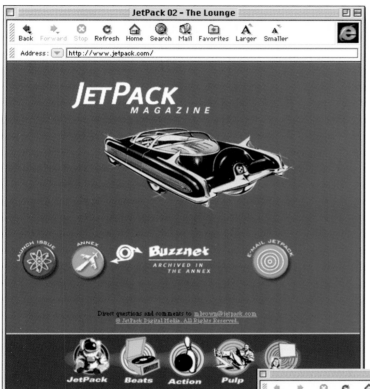

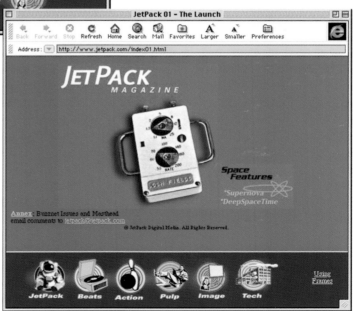

Title
Jetpack Online
Magazine
URL
http://www.jetpack.com/
Design Firm
Jetpack Digital Media
Designer
Mike Levin
Programmer
Marc Brown
Authoring Platform
Mac

Jetpack uses flashy, bright colors to remind you of a future that never happened. It's a combo-1950s/retro-chic-of-tomorrow, where cars with fins recede into the distance on a vibrant dark-blue field, almost like they're flying. The icons are all of the atomic age: spacemen, portable record players, bowling pins, and jet planes. Bright colors or semi-psychedelic, concentric circles of contrasting hues sit behind the links.

title
BoxTop Software, Inc.
URL
http://www.boxtopsoft.com/
Design Firm
MWB Interactive/invisible, ink.
Designer
Ed Sultan, invisible, ink.
Illustrators
Daniel Thomas, MWB Interactive; Ed Sultan, invisible, ink; Travis Anton, BoxTop Software, Inc.
Photographer
Travis Anton, BoxTop Software, Inc.
Programmers
HTML—Ed Sultan, invisible, ink; Travis Anton, BoxTop Software, Inc.; CGI—Danny Lowe, BoxTop Software, Inc.; Travis Anton, BoxTop Software, Inc.; JAVA—Open Cube Technologies
Writer
Travis Anton, BoxTop Software, Inc.
Authoring Platform
Mac

BoxTop Software assigns a color to each of its six products. The color is repeated in three places: as a Try It Today banner, as a vertical bar next to the description on the home page, and then again on the product's page as a horizontal bar with the product name knocked out. The yellows and greens used for the rest of the design reinforce a bit of the industrial-strength nature of the company's products, as do the rendered grayscale images. A subtle point: the standout blue on the homepage for the Departments banner is echoed in the bottom navigation bar on each page that takes you to each area.

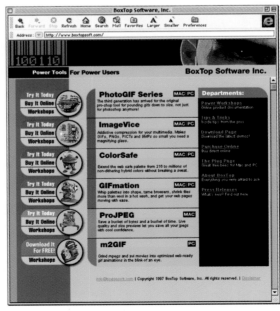

title
gURL

URL
http://www.gurl.com/

design firm
gURL

designer/illustrator
Rebecca Odes

programmers
Sonya Allin, Esther Drill

authoring platform
Mac

gURL is aimed at young, female readers, but the color scheme is purposely not girlish. Purples, reds, greens, and yellows are used on every page, often butted against each other to create an optical illusion of flashing contrast where they meet.

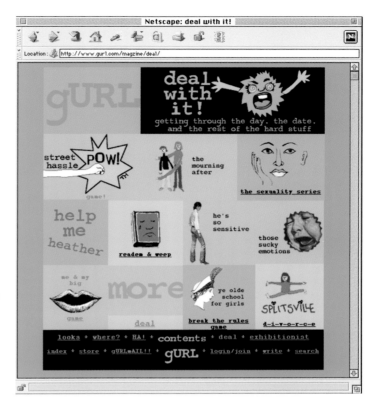

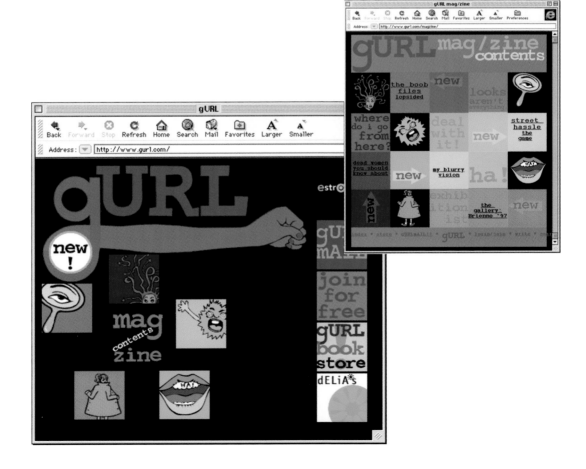

title
KING-FM Radio
URL
http://www.king.org/
design firm
usweb seattle
designers
Kristin Ingalls, Mark Fromson,
David McKeague, Dan Riley
programmers
Bob Cotrell, Dan Riley
authoring platform
Mac, Unix, PC

As the Web site for a music station featuring classical music, the design needs to portray an environment as classic—and classy—as the symphonies that are played. The photos of instruments are rich in color against the black background, counterbalanced by navigational buttons in royal-violet gradations.

Title
fallen angel studios
URL
http://www.fallenangelstudio.com
design firm
knight errant design
designer/illustrator/programmer
bob libby
authoring platform
pc

Moody and introspective, this is a site that uses black not only as an all-purpose background, but to curl around the multicolored images that are the centerpiece of this online gallery. Notice how, in most images, there is no defining outline; the black tries to creep into every pixel.

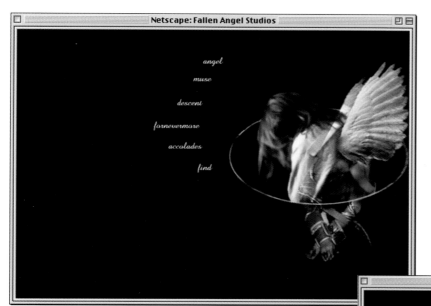

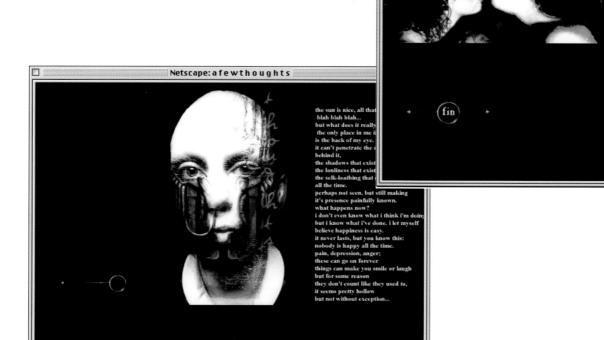

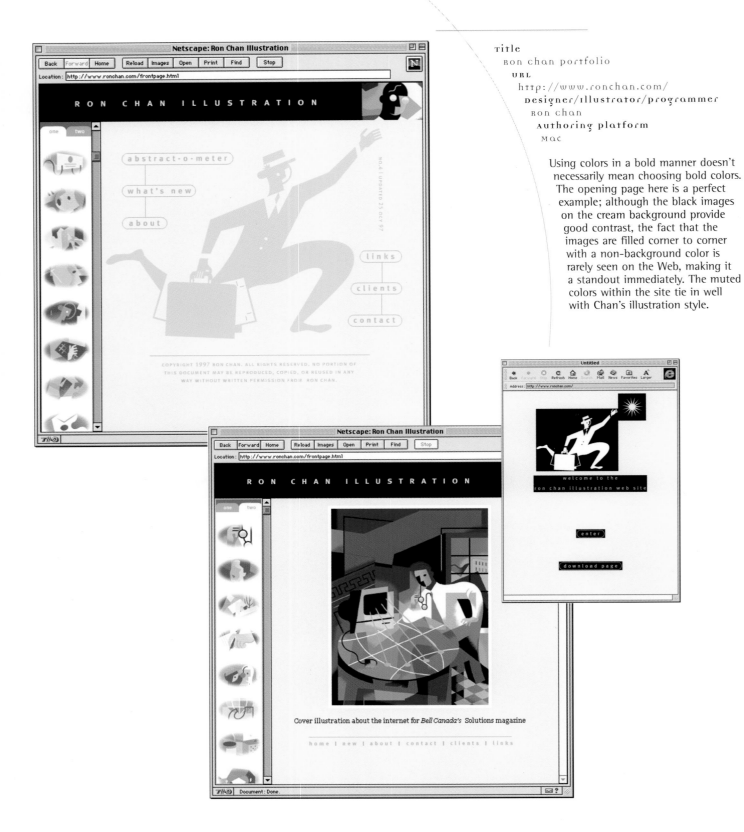

TITLE
Ron Chan portfolio
URL
http://www.ronchan.com/
Designer/Illustrator/Programmer
Ron Chan
Authoring platform
Mac

Using colors in a bold manner doesn't necessarily mean choosing bold colors. The opening page here is a perfect example; although the black images on the cream background provide good contrast, the fact that the images are filled corner to corner with a non-background color is rarely seen on the Web, making it a standout immediately. The muted colors within the site tie in well with Chan's illustration style.

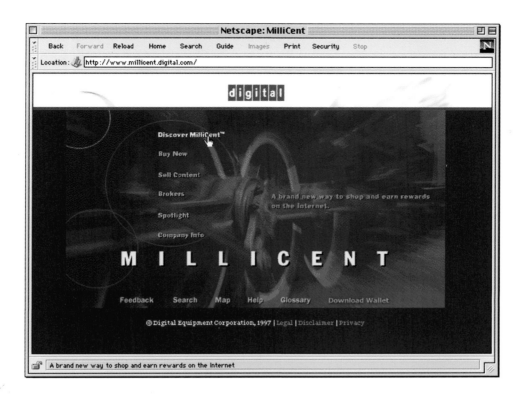

TITLE
MilliCent

URL
http://www.millicent.digital.com/

DESIGN FIRM
organic online inc.

DESIGNER
Jennifer Martinez

INFORMATION ARCHITECT
Bjorn Heinrichs

ACCOUNT MANAGER
Meghan O'Leary

PRODUCER
John Bagby

ASSOCIATE PRODUCER
Greg Black

ENGINEER
Orion Letizi

CONTENT ENGINEER
Rocky Mullin

STRATEGIC PLANNER
Polly Arenberg

A duotoned background is a good way to add texture to a site without causing the distraction of a full-color image. Although the train image is appealing, what makes this page stand out is the contrasting strip of white at the top. It isolates the Digital brand logo while remaining tied to the blue content area by extending the duotone with wisps of blurred pixels.

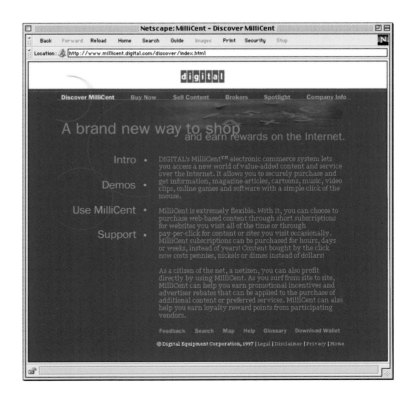

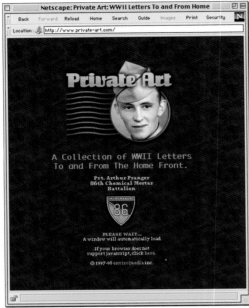

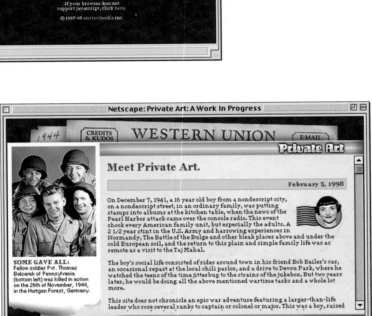

title
private art: a collection of wwii letters to and from the home front
url
http://www.private-art.com/
design firm
enviromedia, inc.
designer/illustrator
rebecca pranger
programmer
larry pranger
authoring platform
mac

Designers whose eyes have gone fuzzy know that creating a good background pattern is much more difficult than it appears. The feathery green background here not only makes for a great texture, but also complements the warm beige and khaki colors used to create the 1940s wartime feel of this well-designed site.

Title
salon magazine

URL
http://www.salonmagazine.com/

Design firm
salon magazine

Designer
mignon khargie ("girl in landscape", "commitaphobe's comeuppance");
karen templer ("mutiny on the net")

Illustrator
adam mcauly ("mutiny on the net")

Writer
jonathan lethem ("girl in landscape")

Authoring platform
mac

Salon has established itself as one of the best-designed sites on the Web, and for good reason. The generous use of white space tends to highlight everything, especially the ever-changing opening screens for different sections (such as Unzipped, shown here). Link highlight colors regularly adapt to the site's title illustrations, subtly forcing a consistency that isn't often encountered.

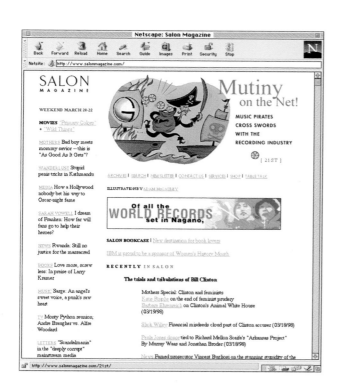

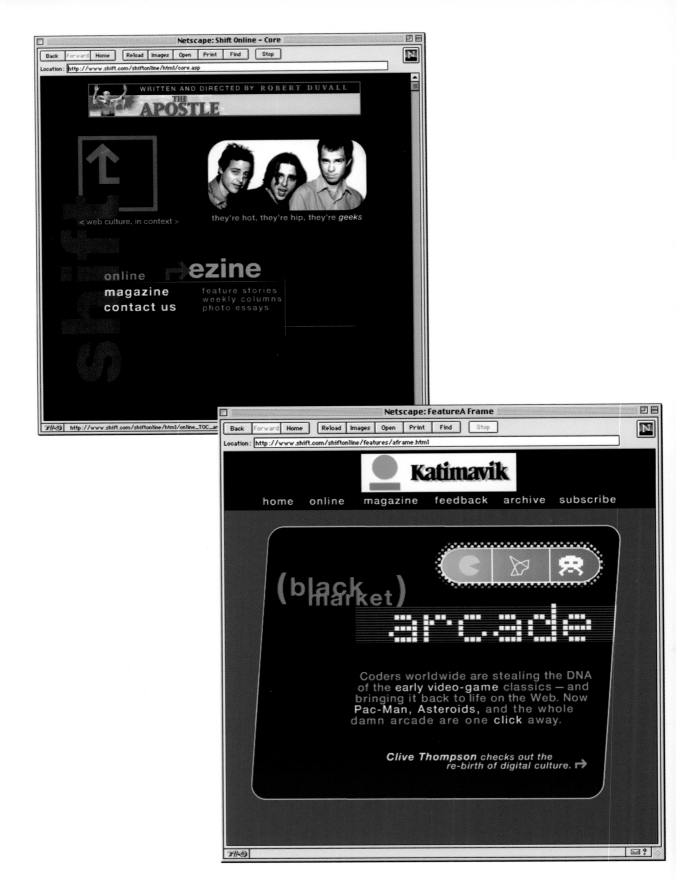

title
shift online
URL
http://www.shift.com/shiftonline/html/core.asp
designers
Barnaby Marshall, Dave Sylvestre
programmer
Al Baghal
Authoring platform
Mac

One advantage to publishing a Web-based
magazine is the flexibility afforded designers
to customize pages to fit editorial content.
With a base black-and-gray color scheme,
this site takes advantage of the ability to
add a variety of color to its features pages
and headline text.

Title
Urban Desires
URL
http://www.desires.com/
Design Firm
Agency.com
Designer/Illustrator
Jean Esquivel
Programmer
Mike Parker
Authoring Platform
Mac

The creators of this site don't want to use urban to reflect anything vaguely reminiscent of a typical real-life city. No, here you get the feeling of being in a crowded, steamy metropolis: red, black, gray, and mustard colors have the gritty tone brought on by lack of direct sunlight. At the same time, however, you're likely to encounter white, blue, and purple hues— an ever-surprising paradise nestled deep within the city.

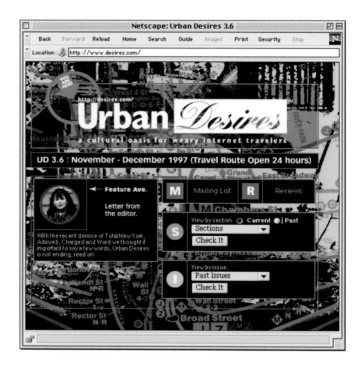

Title
Montgomery Pfeifer, Inc.
URL
http://www.mp.com/
Design Firm
Montgomery Pfeifer, Inc.
Authoring Platform
Mac

It's hard to argue with vibrant colors. Not only are the bright background colors different on every page, the navigational elements in the foreground are equally attention grabbing.

title

smarty pants Magazine

URL

http://www.smartypantsmag.com/smartypants/index.html

Design Firm

Gotham Interactive

Designer/Illustrator

Emma Gardner

Logo

susan sears

Icons

Liz Titone

programmer

paul sullivan

Authoring platform

Mac, pc

With its lime-green accents and maroon stars, this late
1990s site with its 1970s color scheme practically oozes
culture. The multicolored navigation bar on the left side
of the main page establishes this site's mood; solid
swatches of pastels and earthy hues framing internal
pages make them both appealing and readable.

TITLE
elliott/dickens
URL
http://www.elliottdickens.com/
DESIGN FIRM
elliott/dickens
DESIGNERS
percy wang, Dave cook, cardinal o'neill, chris Tiernan
PHOTOGRAPHER
jack christiansen
PRODUCERS
Ted Ganchiff, Andy Laing
AUTHORING PLATFORM
Mac, pc

White is used as a strong visual element on these pages: it is the dominant color, and given the propensity for long, horizontal pages, the color becomes a real visual element, out of which photographs leap and against which the designers array smaller, solid color fields. Typically, each section has a color assigned to it, but these colors are used in subtle ways, like the red quotation marks on the page just off from the homepage. Or, like the way in which the word *cool* is in a medium blue that contrasts well both against the darker blue of the left color bar and still reads against white as it runs to the right.

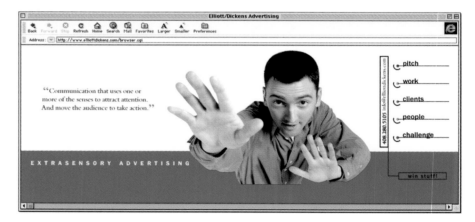

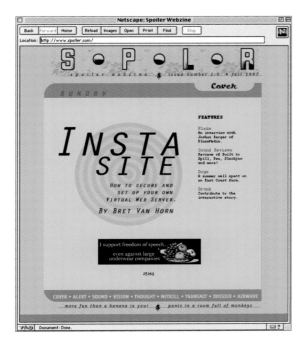

TITLE
spoiler webzine
URL
http://www.spoiler.com/
DESIGN FIRM
spoiler media
DESIGNER/PROGRAMMER
Bret Van Horn
AUTHORING PLATFORM
Mac, Unix

Webzines have been able to get away with color schemes that would normally make print publishers cringe. Without the pressure of visual competition on a newsstand, Webzines like this can use a combination like dark mustard and brownish-orange to quickly establish a tone before the reader even gets to the site's content.

title
souldanse: Art for the soul
URL
http://www.souldanse.com/melanie/
Designer
Melanie A. Ceraso
Illustrator
paul pearson
photographer
Dave siekaniec
programmers
John M. Carlin, Melanie A. Ceraso
Authoring platform
PC

Transparency isn't normally regarded as a compelling Web feature, but this site's use of transparency accents an already beautiful design. The way in which the figures in the upper-right corner of the screen cross at least four levels of color gives the page depth in an unexpected manner.

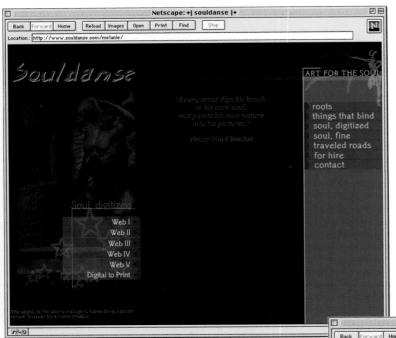

title
soulflare
URL
http://www.soulflare.com/classic/
designer/programmer
Lance Arthur
authoring platform
pc

Without even entering the site, the use of color
here is impressive. To gain access requires clicking
the circle below the figure's extended hand; when
the mouse pointer contacts it, the page lights up
with color. Inside, the tan-and-blue color scheme
holds the black frame in place in an almost
reassuring manner.

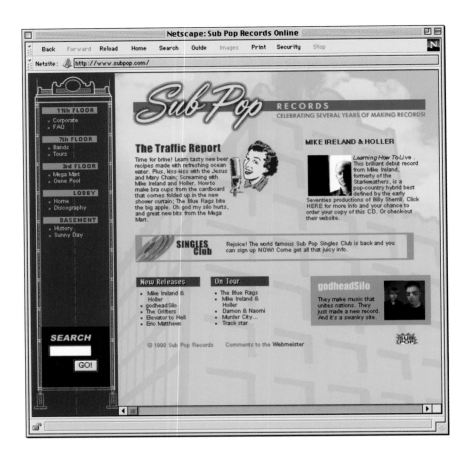

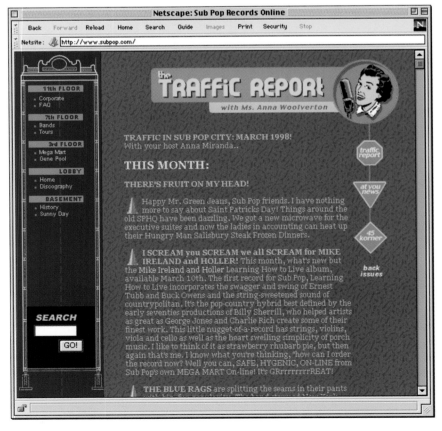

title
sub pop records

url
http://www.subpop.com/

designer
joe walker

programmers
ian dickson, ed slocomb, joe walker

Variations of green dominate this site, though you won't find any forest or hunter shades. The colors, combined with 1950s-era-inspired typography, give the site a vintage feel while featuring up-and-coming bands.

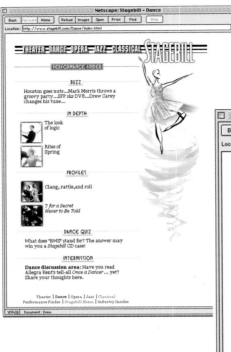

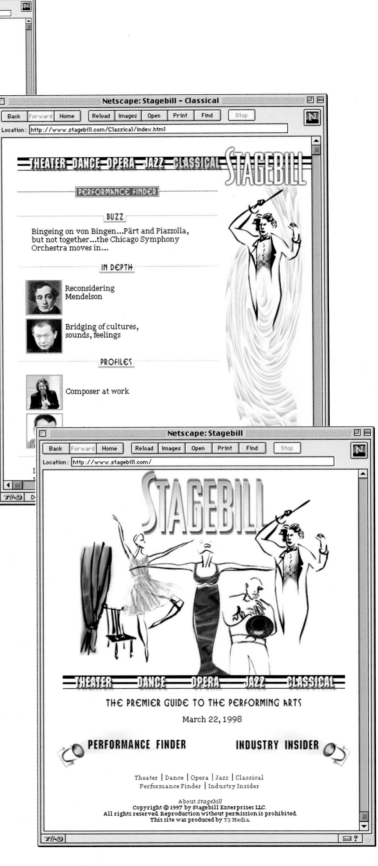

TITLE
stagebill
URL
http://www.stagebill.com/
DESIGN FIRM
T3 Media
DESIGNERS/ILLUSTRATORS/PROGRAMMERS
Chris Bryant, Michael Diamant
PRODUCER
Shira Kalish

To maintain the artsy feeling of using hand-drawn artwork, the designers here have limited their use of colors to the sketched figures representing each area of the site. Like many other sites, the generous use of white space serves to push the color to the forefront, deliberately leading the viewer's eyes and tying together other elements on the page.

Title
The Briar Press Home & Online Letterpress
Museum
URL
http://www.westnet.com/~bpress/index.html
Design firm
One Art Design
Designer/illustrator/programmer
Eric C. Nevin
Authoring platform
Mac

These pages show an interesting mix between warm and cold colors. The tan accents are certainly warmer, but what about the background? Fluctuating between brown and violet, the dominant color here succeeds in portraying a warm, professional appearance. Particularly well done is halving the background and adding white, which highlights the collection of antique presses.

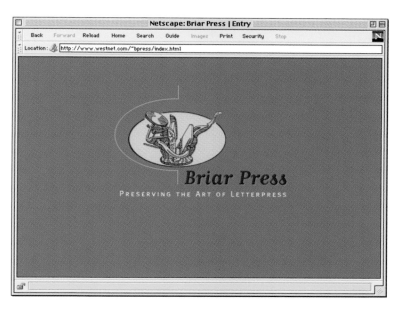

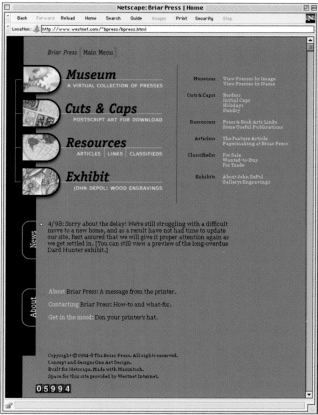

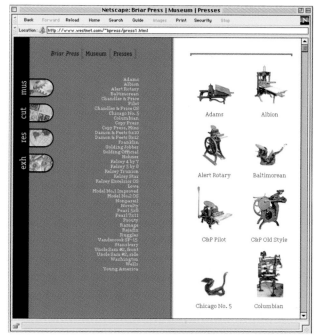

Title
web page Design for Designers
URL
http://www.wpdfd.com/
Design firm
pixel productions UK
Designer/Illustrator/
photographer/programmer
Joe Gillespie
Authoring platform
Mac

There are hundreds of how-to sites geared toward Web designers, but surprisingly few that cover design theory instead of HTML tutorials. This site establishes its professional feel with its minimal—but highly effective—use of bright colors in the main title and as accents. The horizontal pinstriped background subtly enhances the readability of the site's white content without straining the reader's eyes.

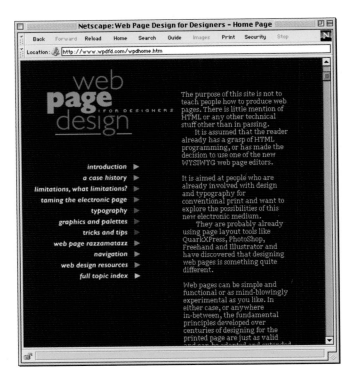

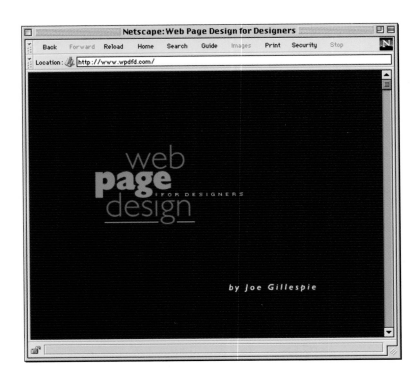

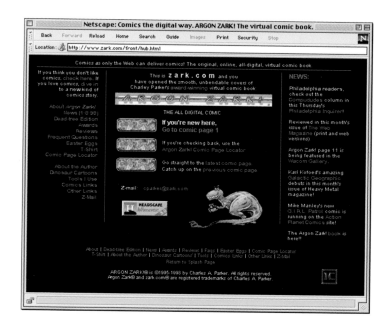

Title
zark

URL
http://www.zark.com/

Designer/Illustrator/Programmer
charley parker

Authoring Platform
Mac

It was only a matter of time before comics built a home for themselves on the Web; this site has contented itself with building a small mansion. The colors are vibrant and obviously computer-generated, lacking the halftoning problems inherent in printed comic books; color gradations, especially on monitors with higher than 8-bit color, are smooth and refined.

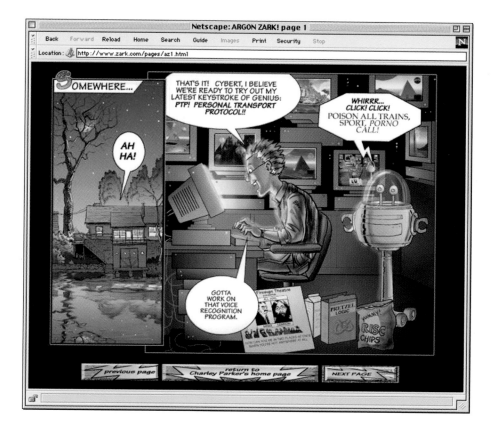

Title
A simple world internet technologies
URL
http://www.simpworld.com/asw-800x600/frame.html
Design firm
A simple world internet technologies
Designer/programmer
Michael Vandor

Here is another example of how a high-quality background can add depth to a simple page. The sandy stone behind pushes the burgundy lettering and image forward. Interior pages use detailed backgrounds that offer context, while remaining secondary page elements.

Title
fractal cow studio
URL
http://www.fractalcow.com/
Design firm
binary-soup.com and fractal cow studio
Designer/illustrator/photographer/programmer
Dino Ignacio
Authoring platform
pc

Color blends can be used to great effect in small doses, as evidenced on this opening page. The purple-and-yellow gradations point out that this is no ordinary cow, while the red swatch identifies the studio's title. One section of the site, a digital cartoon, relies on bitmapped black-and-white imagery, but dabbles in color where it's most appropriate to the narrative.

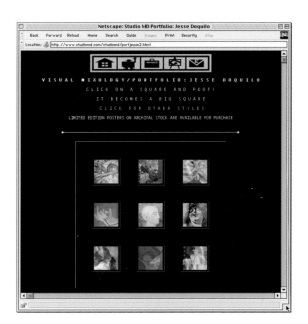

Title
studio M D
URL
http://www.studiomd.com/
Design Firm
studio M D
Designers
Glenn Mitsui, Randy Lim, Jesse
Doquilo
Illustrators
Glenn Mitsui, Jesse Doquilo
Programmer
Tim Celeski
Authoring Platform
Mac

Yellow never seems to get the credit it is due. Set against the black on these pages, the yellow navigation and text links provide plenty of color without flooding the page with colored pixels. The artwork showcased inside jumps off the screen, thanks to the minimal palette used by the navigational elements.

TITLE
studiomotiv
URL
http://www.studiomotiv.com/
studiomotiv/home/home.htm
DESIGN FIRM
studiomotiv
DESIGNERS
Brett Collins, Ed Stull, Robert Abbott
ILLUSTRATOR
Brett Collins
PROGRAMMERS
Bill Litfin, Paul Rothrock
AUTHORING PLATFORM
PC

Another black background, but this time the burnt orange of the text and the illustration, combined with white titles and layered typographic texture, constrain the black as only the page's backdrop. Once past the opening, white dominates, with gray and a lighter orange for highlights.

Title
KMTT-FM
URL
http://www.kmtt.com/
Design Firm
US Web
Designers
Kristin Ingalls, Mark Fromson
Programmer
Bob Cottrell
Authoring Platform
Mac, PC

As shown here, soft colors can produce hard results. What would normally be an eye-straining swirl, the peach-colored twister in the background adds texture to intentionally sparse pages. This allows the viewer to concentrate on the more colorful navigation on the right, and the content that appears in the main frame.

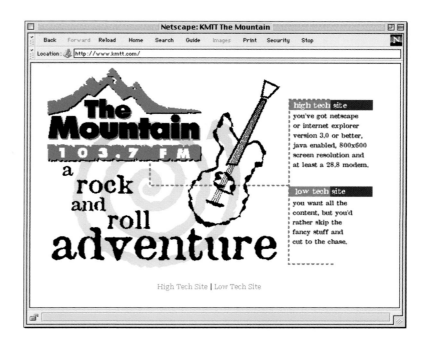

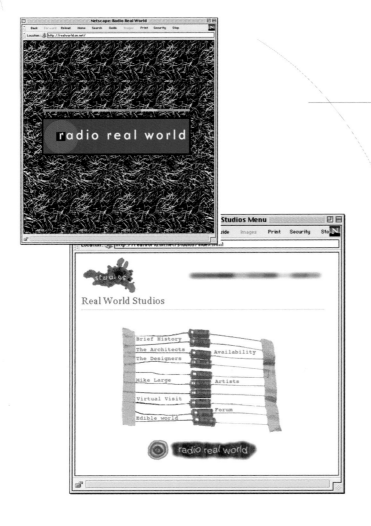

Title
Radio Real World
URL
http://realworld.on.net/
Design Firm
Real World Multimedia
Designer/Illustrator/Photographer/Programmer
York Tillyer
Authoring Platform
Mac

Many Web designers, striving to make their sites inviting, often turn homepages into scavenger hunts and then wonder why no one bothers to click on every icon in sight. Here, however, color is navigation: Set against the highly textured grayscale background, the colored bars entice exploration through directness and clarity.

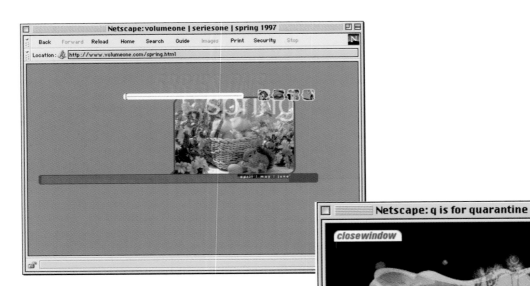

TITLE
volumeone
URL
http://www.volumeone.com/spring.html
DESIGNER/PROGRAMMER
Matt Owens
AUTHORING PLATFORM
MAC

Many sites that use color well tend to
select a limited palette and stick to it,
ensuring consistency among their pages.
But it's also perfectly acceptable to use a
broad set of colors, such as the flat-green
and tan background of this spring page.
Clicking the icons brings up small windows
that use color schemes specifically tailored
to each window's content.

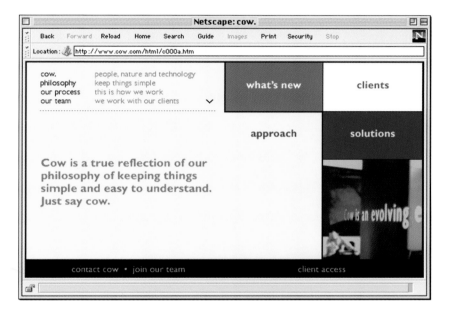

title
cow. interactive communication
URL
http://www.cow.com/
Design firm
cow. interactive communication
Designers
Bryan powell, Tex otto
programmers
jonathan santos, thierry benichou
Account Director
Drew sievers
creative Directors
Bryan Dorsey, Mateo Neri
technical Director
jonathan santos
content Manager
steven Lovy
Backend Engineer
tammy mckean
copywriters
Bryan Dorsey, steven Lovy,
Tom pope, Brian higa

This site is one of the best examples of using a limited number of colors to maximum effect. The four main colors are splashed over large areas and text is displayed using the same colors, dark on light and light on dark. Black is the only odd color out, and is used sparingly.

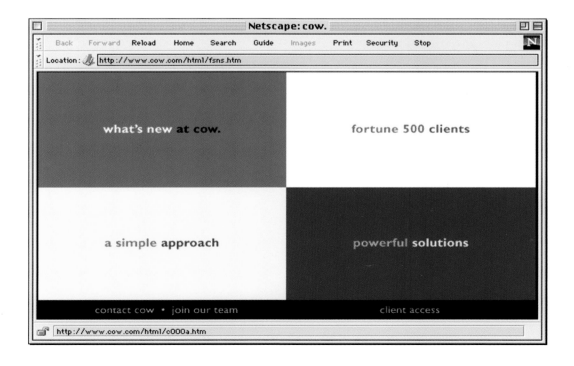

title
212
url
http://www.212.net/
design firm
madisonavenue.com
illustrators
David Haadler, Sue Ann Kim,
Marianna Trofimova
photographers
Emilie Wilson, David Haadler,
J. Michael Seyfert
programmers
Kevin Toye, David Haadler,
John Northrop, Jill Penning,
J. Michael Seyfert
creative Director
J. Michael Seyfert
Authoring platform
PC

The multicolored background serves
to separate and reiterate the
skyscraper-esque bars of information
in this New York-based e-zine.
The effect is immediately striking
and intentionally places the viewer
into a world of density and variation.

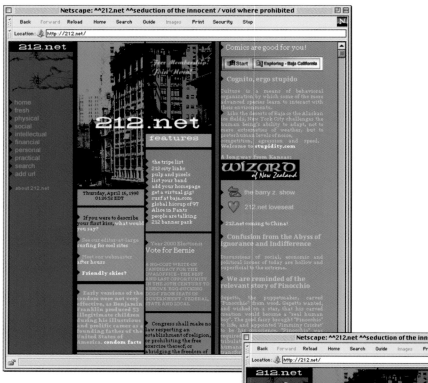

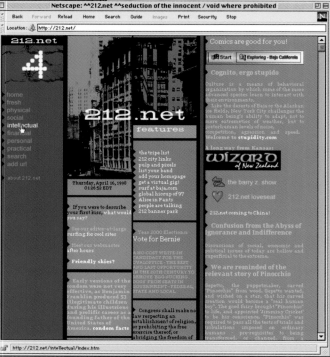

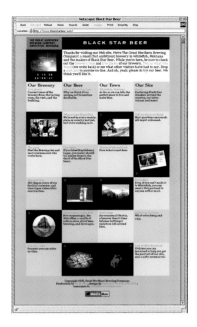

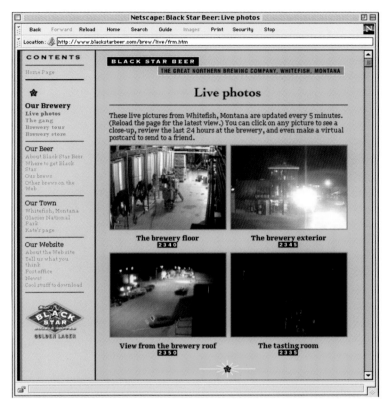

title
BLACK STAR BEER
URL
http://www.blackstarbeer.com/
Design firm
DCL (Doris and Clancy, Ltd.)
Designers
Doris Mitsch, Clancy Nolan
photographers
Doug Menuez, Mike Calabro,
Amy R. Colson
programmer
MediaMax
writers
Toby Barlow, Doris Mitsch,
Kate Greenlee
Authoring platform
Mac, PC

Cleverly hidden in full view on this site is
the fact that there is a lot of information
being pushed on the homepage. Rather
than offer multiple boring lists of links,
the designers have spread out across a
two-toned checkerboard. The golden
colors evoke the lager offered by the
brewery, and make the photos in the
black boxes pop off the screen.

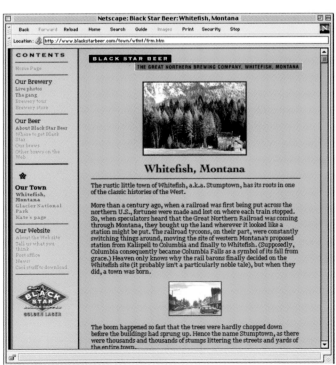

Title
Bohem Interactive
URL
http://www.bohem-int.com/
Design Firm
Bohem Interactive
Designer/Photographer
Bonnie Lebesch
Illustrators/Programmers
Bonnie Lebesch, Don Barnett
Authoring Platform
Mac

This site for an award-winning multimedia CD-ROM remains true to its source, keeping text to a minimum and showcasing the program's quirky colors and artwork. The blue background tile provides a perfect bedspread on which to lay out the CD's musical demos.

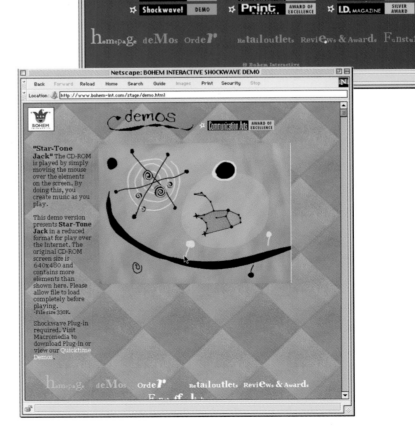

Title
Lunar Prospector

URL
http://www.lunar.arc.nasa.gov/index.html

Design Firm
NASA Ames Research Center

Designers
Ken Bollinger, Glenn Deardorf, Jeffrey Ma

Illustrators
Jeffrey Ma, Justin Hafford, Lisa Chu-Thielbar, Alison Davis

Programmers
Larry Kellogg, Jonathan Yee

Authoring platform
Mac, PC, Unix

Much of the space imagery we see has turned into visual clichés, which is why the unexpected arc of the Earth on the right side of this homepage is refreshing to view. The designers at NASA have tapped images that transcend what is normally seen: the Earth, with its cloud-swept blue oceans, and the Moon, containing multiple layers of detail not usually seen with the naked eye.

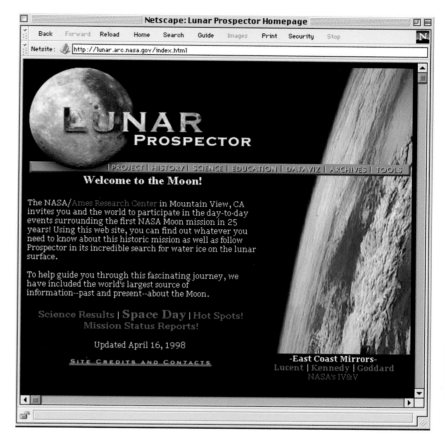

title
Meany Theater-uw world series
URL
http://www.meany.org/
Design firm
Accelerated web Development/Hinton and steel
Designers
Jeff Deroshia, Judy simpson, Jesse Damm
photographer
KAN photography
programmer
Accelerated web Development
Authoring platform
PC

The main image on this site isn't remarkable for a broad use of colors, but rather for the smoothness of the blends and fades, both in the water-map and the blue-green strip at the top of the page. On a pixel-by-pixel basis, this page fills up the Web's limited 256-color palette with similar hues, retaining its smoothness, even on 8-bit displays.

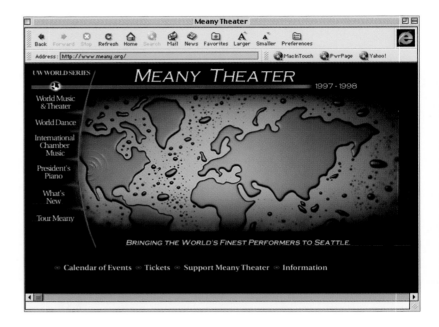

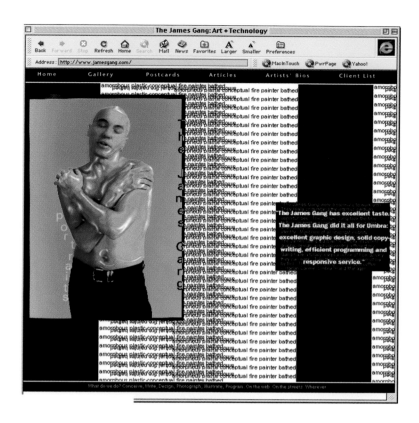

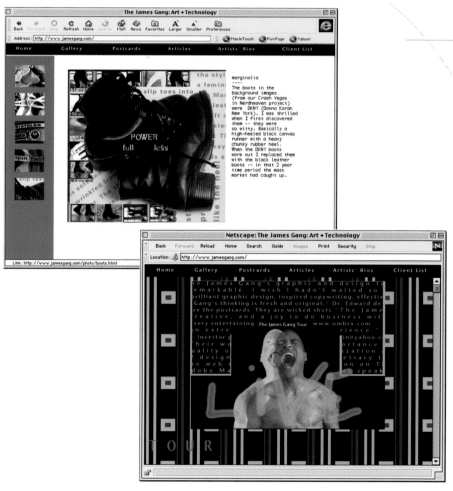

title
The James Gang
URL
http://www.jamesgang.com/
design firm
The James Gang: Art + Technology
designers
Franke James, MFA; Bill James
illustrator/photographer
Franke James, MFA
programmer
Bill James
models
Ronnae (Ford Models)
Authoring platform
Mac

Many sites that use color successfully prefer to maintain visual consistency and control. The James Gang, however, uses color as an explosion, often letting it fall where it may. Whether added for dramatic emphasis, as on the figure on the main page, or as a patterned background, color on this site remains unbound.

TITLE
vivid studios
URL
http://www.vivid.com/
DESIGN FIRM
vivid studios
PHOTOGRAPHERS
Brian Bell, Chuck Gathard,
Marsha Plat
PROGRAMMERS
Paul Guth, Nat Johnson
CREATIVE DIRECTOR
Nathan Shedroff
INFORMATION DESIGNER
Drue Miller
VISUAL DESIGNERS
Jeff Davis, Nathan Shedroff,
Maurice Tani
WRITER
Drue Miller
AUTHORING PLATFORM
Mac, Unix

This studio is selling itself to an elite
clientele, and the royal purple on the
homepage feels sophisticated. Mostly
shades of purple and green are used,
but the reversed-out center vertical
panel—reversing the purple hand to
green—creates three distinct areas
from left to right that don't
interfere with separate navigation
and link actions from top
to bottom.

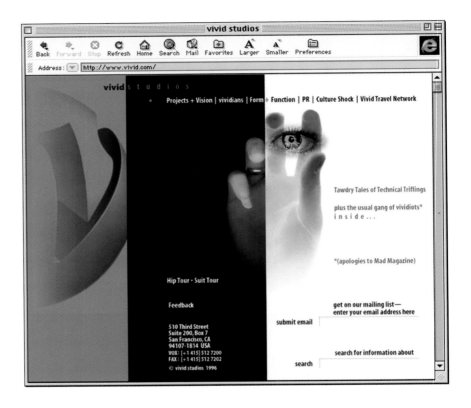

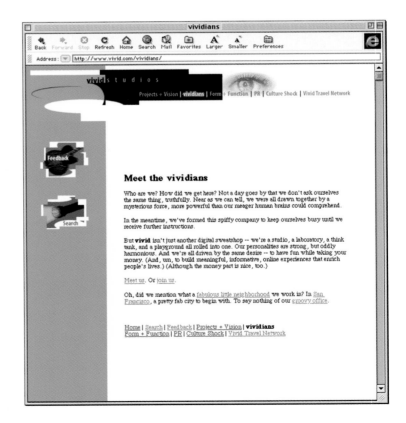

title
Mike Motz: promotional portfolio
URL
http://www.cal.shaw.wave.ca/~mmotz/
Design Firm
Mike Motz
Designer/Illustrator/Programmer
Mike Motz

An artist who is promoting, in part,
his cartoon style, the colors come from
the TV animation palette. Although it
seems to be more active, the color
palette is surprisingly small: a light,
medium, and dark pastel green; plus
red, blue, and yellow. Almost everything
else uses shadowed versions of those six.
In a nice, small touch, his red signature
has a green shadow, which changes to
the contrasting green for whichever
area the signature covers.

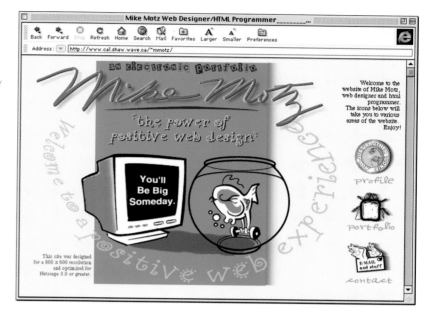

Jeff Carlson

Jeff spent several years doing desktop publishing before jumping into the Web publishing arena by founding and editing *eSCENE*, the Internet's only yearly anthology of the best short fiction appearing on the Web. A stint as Managing Editor at a small Seattle-based book publisher convinced Adam and Tonya Engst that they should tap him for the same position at the widely-read newsletter *TidBITS*. Jeff has published articles in *HOW Magazine*, *Macworld*, and *Adobe Magazine*, and was a contributing editor and columnist for Adobe's online venture, *adobe.mag.* He is also the author of *The Palm III/PalmPilot Visual QuickStart Guide*. In addition to writing and editing, he's an accomplished Web designer and consultant through his company Never Enough Coffee creations. People around him seem to possess strong urges to constantly ask him questions. <http://www.necoffee.com>.

Toby Malina

In 1995 Toby joined Thunder Lizard Productions, a Seattle-based conference production company, as Editorial/Technical Director. At Thunder Lizard, she worked in collaboration with the editorial staff and outside experts in the desktop publishing and Web design fields to develop editorial content for The Photoshop Conference, The Adobe Internet Conferences, and Web Design: HTML and Beyond, amongst many others. In addition, Toby was responsible for the coordination and execution of all conference audio visual including computer systems, lighting, sound, and projection. If it broke, she fixed it. In 1997 she served as product manager for Technique: Digital Artists at Work and The PageMaker Summit.

For the past ten years, Toby has also worked independently as a graphic designer and Macintosh consultant. Her multi-faceted roles have included art director, production artist, MIS manager, software/systems trainer, and mental health professional. Her greatest triumph: wrenching a motherboard from the jaws of a client's basset hound and successfully reseating it.

Glenn Fleishman

Glenn Fleishman has written about technology and its use in several publications, including *InfoWorld* and *NetGuide*. He was a founding contributing editor and columnist at the print edition of *Web Developer* (now only found on the Web), and is a contributing editor and columnist for *Adobe Magazine*, where he writes the Web Watcher column. Glenn was course manager at the legendary Kodak Center for Creative Imaging in Camden, Maine, and later worked doing scanning and color correction at a showcase imaging center nearby, High Resolution Inc. Glenn later worked as a managing editor for Open House, where he technical- and copy-edited several books for Peachpit. He founded one of the first web development companies, Point of Presence Company (POPCO), offering firms Web site programming and hosting. While at POPCO, he helped broadcast the first feature film over the Internet. Glenn worked briefly as a senior manager at Amazon.com Books; while there as catalog manager, he was responsible for increasing the catalog from 1 million to 2.5 million titles. He now works as a consultant, conference chair, writer, and itinerant perl programmer, and recently co-authored the second edition of *Real World Scanning and Halftones*. <http://www. glenns.org>

AdEra Digital Media AB
Ostra Hamngatan 41-43
41110 Gotenburg
Sweden

Lance Arthur
76 Lexington Street
Auburndale, MA 02166

Artseensoho
28 East 10th Street
New York, NY 10003

AT&T
295 N Maple Avenue
Basking Ridge, NJ 07920

Atlas
1201-B Howard Street
San Francisco, CA 94103

Blind Visual Propaganda
2020 North Main Street #235
Los Angeles, CA 90031

Bohem Interactive
2226 Eastlake Avenue East
Suite 61
Seattle, WA 98102

Boxtop Software, Inc.
101 North Lafayette Street
Starkville, MS 39759

Canary Studios
600 Grand Avenue
Suite 307
Oakland, CA 94610-3500

Ron Chan
24 Nelson Avenue
Mill Valley, CA 94941

Chris Chomick
5248 52nd Avenue N
St. Petersburg, FL 33709

Community Network Systems
4 Hasadna
Jerusalem, Israel

Contempt Productions
144 W 23rd Street #116
New York, NY 10011

cow. Interactive
Communication
1522 Cloverfield Boulevard
Suite E
Santa Monica, CA 90404

Dartmouth College Curricular
Computing
Kiewit Computation Center
Hanover, NH 03755

The Design Office, Inc.
1 Bridge Street
Irvington, NY 10533

DigitalFacades
1750 Fourteenth Street
Suite E
Santa Monica, CA 90404

Elliott/Dickens
97 South Second
San Jose, CA 95113

Emergent Media, Inc.
1809 7th Avenue
Suite 908
Seattle, WA 28201

Enviromedia, Inc.
617 Vine Street
Suite 1336
Cincinnati, OH 45202

Focus2
2105 Commerce
Suite 102
Dallas, TX 75201

52mm
12 John Street
10th Floor
New York, NY 10038

Fractal Cow Studio
2 Achilles Street
Acropolis, Libia
Quezon City, Metro Manila
Philippines, 1100

frogdesign
1327 Chesapeake Terrace
Sunnyvale, CA 94089

Funny Garbage
73 Sprung Street
Suite 605
New York, NY 10012

Goblin Design
Josef-Reiert-Strasse 4
69190 Walldorf
Germany

The Grapevine
321 University Street
Healdsburg, CA 95448

Gr8
2400 Boston Street
3rd Floor
Baltimore, MD 21224

Graffito/Active8
601 North Eutaw Street
Suite 704
Baltimore, MD 21201

Gravica Design Group
1260 Woodland Avenue
Springfield, PA 19064

Hon Hiew
Q-Multimedia
10 Eastland Street
Dianella, Perth, WA, 6059
Australia

HOW Magazine Web site
1507 Dana Avenue
Cincinnati, OH 45207

ICE Magazine
P. O. Box 3043
Santa Monica, CA 90408

The Iconfactory
1 Moss Cove Court
Greensboro, NC 27407

Internet Underground Music
Archive
303 Potrero Street
Suite 7A
Santa Cruz, CA 95060

The James Gang: Art +
Technology
3080 Yonge Street
Suite 5044
Toronto, Ontario
M4N 3N5 Canada

Jessica Helfand/William
Drenttel
P. O. Box 159
Falls Village, CT 06031

Jetpack Digital Media
914 Colorado Avenue
Santa Monica, CA 90401

KING-FM Radio
Classic Radio Inc.
333 Dexter Avenue N
Seattle, WA 98109

Kjetil Vatne Graphics +
Design
Langarinden 407
N-5090 Nyborg
Norway

KMTT-FM
1100 Olive Way #1650
Seattle, WA 98101

Knight Errant Design
8948 SW Barbur Boulevard
Suite 168
Portland, OR 97214

Letkrummet Design
Fredsgatan 17
S-17233 Sundbyberg
Sweden

Lisa Marie Nielsen Design
601 Fourth Street, #125
San Francisco, CA 94107

Los Angeles County Arts
Commission
500 West Temple Street
Los Angeles, CA 90012

madisonavenue.com
244 Madison Avenue #424
New York, NY 10016

Montgomery Pfeifer, Inc.
261 Bush Street
San Francisco, CA 94108

Mike Motz
Anythyme Web Design
60 MacEwan Meadow Way
Alberta, Canada

N2K Entertainment
55 Broad Street
New York, NY 10004

Nekton Design
23502 171st Avenue SE
Monroe, WA 98272

One Art Design
P. O. Box 490
Briarcliff, NY 10510

Parent Soup
170 Fifth Avenue
New York, NY 10010

Charlie Parker
112 Maple Road
Wallingford, PA 19086

Phinney/Bischoff Design
House, Inc.
614 Boylstone
Seattle, WA 98102

PING Belgium
Interleuvenlaan 5
B-3001 Leuven
Belgium

Pittard Sullivan
3535 Hayden Avenue
Culver City, CA 90232

Pixel Productions UK
39 Ripley Gardens
London SW14 8HF
United Kingdom

Presto Studios
5414 Oberlin Drive
San Diego, CA 92121

Qaswa Communications
423 Washington Street
Floor 5
San Francisco, CA 94111

Real World Multimedia
Box Mill, Box
Wiltshire SN13 8PL
United Kingdom

Red Dot Interactive
612 Howard Street
Suite 330
San Francisco, CA 94107

Salon Magazine
706 Mission Street
2nd Floor
San Francisco, CA 94040

Shift Online
119 Spadina Avenue, #202
Toronto, Ontario
Canada

Souldanse Digital Design
33 Braxton Lane
Aurora, IL 60504

Spoiler Media
3095 SW 15 Court
Gresham, OR 97080

Stagebill
144 East 44th
7th Floor
New York, NY 10017

Studio MD
1512 Alaskan Way
Seattle, WA 98101

studiomotiv
300 Marconi Boulevard
Columbus, OH 43215

Sub Pop Records
1932 1st Avenue
Suite 1103
Seattle, WA 98101

Teknoland
Almirante, 16-1st Floor
28004 Madrid
Spain

That's Interactive
7th Floor
206 Prince Edward Road
West
Kowloon, Hong Kong

THUNKdesign
293 Missouri Street
San Francisco, CA 94107

Typographic.com
557 Dolores Street
San Francisco, CA 94110

Joshua Ulm
525 Brannan Street
Ground Floor
San Francisco, CA 94107

Urban Desires
665 Broadway
Suite 504
New York, NY 10012

US Web
139 Richmond Street
El Segundo, CA 90245

Vivid Studios
510 3rd Street
San Francisco, CA 94107

Volumeone
654 Metropolitan Avenue
Brooklyn, NY 11211

Yale-New Haven Medical
Center
47 College Street
New Haven, CT 06510

INDEX